FIRESIDE

Wedding

BARBARA NORFLEET

A FIRESIDE BOOK
PUBLISHED BY SIMON AND SCHUSTER

PUBLISHED BY SIMON AND SCHUSTER
A DIVISION OF GULF & WESTERN CORPORATION
SIMON & SCHUSTER BUILDING
ROCKEFELLER CENTER
1230 AVENUE OF THE AMERICAS
NEW YORK, NEW YORK 10020

DESIGNED BY EVE METZ
MANUFACTURED IN THE UNITED STATES OF AMERICA
PRINTED BY RAPOPORT PRINTING CO.
BOUND BY THE BOOK PRESS

1 2 3 4 5 6 7 8 9 10

LIBRARY OF CONGRESS CATALOGING IN PUBLICATION DATA
NORFLEET, BARBARA.
WEDDING.
1. WEDDINGS—HISTORY—PICTORIAL WORKS.
2. WEDDING PHOTOGRAPHY—HISTORY. I. TITLE.
GT2665.N67 779'.9'39250973 79-12238
ISBN 0-671-24397-7
0-671-24564-3 PBK.

Acknowledgments

This book is a greatly expanded version of a catalog for an exhibition I organized in 1976 for the Carpenter Center for the Visual Arts, Harvard University.

Early in the collecting process I realized that wedding photographs in America were infinite and I decided to emphasize the behavior of the couple, their friends and their family before, during and after the wedding. I also wanted to show how people revealed themselves in formal portraits. I was less interested in the marriage ritual and the many ethnic and bizarre variations within it.

I did the collecting while teaching at Harvard. Although New England studios are overrepresented, the photographers and their subjects represent many different locales, religions, races, incomes and historical styles. I ultimately chose to limit the candids to the work from seven professional studios, and most of the pictures in this book come from the print and negative files of these studios. I express my deepest thanks to these seven photographers for giving me access to their files: the Bradford and Fabian Bachrach Studio with studios in Atlanta, Boston, Chicago, Philadelphia, Providence, New York and until recently in Baltimore, Hartford and Washington; the Orrion Barger Studio in Chamberlain, South Dakota; the Samuel Cooper Studio in Brookline, Massachusetts; the John Deusing Studio (partner: Michael Milakovich) in West Allis, Wisconsin; the John Howell Studio in

Winnetka, Illinois; the Clement McLarty Studio in Boston, Massachusetts; and the Martin Schweig Studio (partner: Frank Ferrario) in St. Louis, Missouri. Their generous cooperation made this book possible.

Many other sources gave assistance in the search for photographs: Underwood and Underwood, the James Van der Zee Institute, Magnum Photos Inc., The Museum of the City of New York and the State Historical Society of Wisconsin. I express my appreciation to the staffs of these institutions and to the many other individuals who gave me photographs from their own albums.

For their individual help and support I am indebted to the following: Lucille Chapman at the Bachrach Studio; Burton Projansky at the Samuel Cooper Studio; Bob Ely who helped with the printing; Lise Newcomer who helped with making contacts of negatives; Bobbi Carrey and Adrienne Linden for continuing help and support. I thank Roger Brandenberg-Horn, Stephen Cohn, George Cossette, Patricia Degener, Elsa Dorfman, Peter Galassi, Marvin Israel, Michael Lesy and Dale McConathy for sharing their ideas with me.

I give special thanks to two people—David Riesman whose scholarship and observations on America have influenced me greatly during the years I have known him and to John Szarkowski who gave encouragement, advice and support when needed.

I am grateful to the staff of the Carpenter Center: to Eduard Sekler and Robert Gardner for their continuing support of photography and The Photography Archive; to Laura Herring, Holly Holmes, Marjorie Kane, Hope Norwood and Cynthia von Thuna for administrative and secretarial help.

The original exhibition was supported by a grant from the National Endowment for the Arts; and collecting photographs outside the New England area was supported by a grant from the National Endowment for the Humanities. The Carpenter Center for the Visual Arts gave added support.

It is the privilege of the photographer to record for others that moment in time . . . to capture forever the tenderness of love so that what exists in today's moment is everlasting . . . an exquisite moment . . . expressing the tender relationship and happiness of two in love on their wedding day.

John Howell
Studio photographer

The photographs in this book are a powerful affirmation of family and marriage. The studio photographers know the talismanic power of their work; they know that the album of pictures and the portrait on display will become part of the household of the new couple and remind them of the hope and confidence placed in them to carry on the family.

The magical importance of these photographs became clear as people looked through their old family pictures for this book. They relived the events these photographs recorded and recalled the vivid feelings and memories evoked about family, friends and places.

People who are invited to weddings know that they are taking part in an important ceremony; they dress and present themselves as they want to be remembered. The visual record which results may be the best we have of the historical changes in fashion, expressions, gestures and manners; and the variations which derive from income, religion, sex and ethnicity.

In 1979 this all may seem irrelevant. The image of marriage is changing, and we wonder about the future of families. The golden age of studio photographers seems to have gone by; but the men who made these pictures knew that they were witness to important commitments and that their pictures could help make these commitments permanent.

Interview with Herbert Talerman
Present director of Bachrach Candid Department

When we started taking pictures for Bachrach we photographers were very, very excited. We had all come from poor families and, working for Bachrach, we saw a world that was totally different from the one we had known. We took pictures of people like the Kennedys and Roosevelts. It was a world we used to dream about but never thought would happen to us. Our excitement showed in our work.

The general direction of the professional field disturbs me very much. It will change the face of the candids. It started when people began to disturb the couple before, during and after the ceremony—stand here, stand there, stand still, cut the cake again and so forth. It won't be the people's wedding anymore; it will be the photographer's. A few stylized and preplanned shots are latched onto, and people don't realize what is happening to them. Twenty years later they will be hit over the head with it—they will miss their wedding. They will have double exposures and trick shots.

When people move to small cameras and negatives, and that is already happening on the West Coast, the thing that will be hurt most will be the pictures of groups of eighteen people or so. You get filters and automated printing, and the small negatives crumble and the group shots border on the unacceptable.

Interview with John Howell: Winnetka, Illinois

I was trained as an investment analyst, but it was in the 1930s and there was no investment to analyze and so I became a "kidnapper" and sold my skills as a child photographer door to door. Photography became my life and my passion.

I do candids but I think of myself as a portraitist. A person is only a portraitist if he can relate to people and do it well. Photographing a person means a lot to their loved ones and it is meaningful even to the individuals themselves. People often think they are not good subjects, but once you make them confident (it is by your own expression that you affect the expression of others) they are good subjects. That's why there can be romanticism about portraiture.

When I do candids I like color because with color it is all there—the people are not just tones of gray. I especially like the wedding candids because they are a truthful story, a record, complemented by total believability through the photographer's art. I don't like the gimmickry of that devised simply for startling effect and sales.

I hope I add to the inner confidence of those who come to me to be photographed.

Interview with Bradford Bachrach: Studios in Atlanta, Boston, Chicago, Philadelphia, Providence and New York

I spent my summers while I was still in high school working in the darkroom, and I saw how much more exciting my work was than the work my friends were doing. At the end of college I thought I might become a teacher, but then I realized I wanted more variety in my life. I wanted to meet all kinds of people—from self-important to everyday people. I thought this was one of the most exciting parts about being a photographer and it has turned out to be. Of course, my family has been in photography for over one hundred years although most of my grandfather's pictures were lost in a fire.

It is unfortunate Bachrach has a snob reputation—people assume we only do business with the carriage trade. In Boston we have broken down the idea that you have to be a Cabot or a Lowell to have us take your picture. It's a good thing because, if you had to depend on the Cabots and Lowells, there are simply not enough of them. There is also another change taking place. The upper-class kids are turning away from wanting formal portraits. They want only candids and stainless steel. It is the ethnic groups who now want the formal portraits and silver. It is part of this whole anti-establishment bit. It isn't as bad as it was a few years ago though.

We began to be interested in candids in the middle thirties, but we didn't really get started until the early 1940s. Candids took off during World War II because of the transportation problem. You didn't need two men and an assistant for candids and a man could grab his hand camera and take a streetcar or subway to where he was going and not worry about gasoline.

I was so busy with portrait work (I did the women mostly and my brother Fabian did the men) that I stuck to that, but my nephew does candids too. I don't want to put down candids, but we portraitists have our eyes on something—a moment of grandeur. A portrait makes us appear as everything we wish we were. It is not just a map of the face. It goes beyond a flat record. It is a person at his best—an exaltation. We all want that kind of record of ourselves, and I know how to do it. Candids are for the moment, but portraits are for all time.

There are fewer and fewer portraitists now. It is a long business and the training and cost go up every year. We have priced ourselves out of the market for the ordinary person unless it is for a very special occasion. Fortunately corporations want portraits and then the person can have some done for himself. Western Europe used to be leaders in portraiture and now the portrait photographer has all but disappeared there. America and Canada have a number left. We are either more romantic or richer, or both.

Interview with James Purcell

I was the director of Bachrach's Candid Department from its beginning in 1940, and although I retired a few years ago I still do weddings when people ask for me. I now do the daughters of parents I once did.

I did portrait and studio work before I did candids. It gives you a standard you carry over to candids, but it's more fun doing candids than formals because you get to know people. I don't say it is more fun because you get to eat or drink at the wedding. Once a photographer sits down and acts like a guest, he begins to miss things. You can't be a guest and a good photographer at the same time. You are too comfortable and too lazy to get the picture. I can always eat.

If you want to do a good candid job you must be a bug on the wall. That is the way to get good pictures. You let the people enjoy their wedding, you don't get in the way, you are not intrusive. You realize the wedding is for their benefit, not the photographer's. Your pictures will then be alive because the people you take will be enjoying their wedding. Certain pictures are a must to take at any wedding—we call them "stock" shots, but the best capture the spontaneity of the day. To do this you must know your work so well that you can do it without bothering people. A good candid man makes no effort to stereotype his work. Often I've done two or three weddings for the same family, and they must let me know if they want a repeat of a picture I took of a sister.

If a photographer isn't at ease with people, he isn't going to get natural pictures. You must be good enough so your attention is on the people, not on the equipment. I don't do these new double exposures or Mistys. I don't want to get set-ups.

Candids have taken over much of the formal work. Even the bridal party is done at the reception with candids. The formal of the bride is taken two weeks before the wedding with fake flowers. They photograph just as well. We do formal family portraits in the home now, but they have nothing to do with weddings.

Today it is common for one set of parents to be divorced and although they will bring their new spouses to the wedding, when it comes to group pictures they often ignore the new wife and daddy poses with his old wife.

Once we lost some film in the mail. We rented suits for the males and we cleaned the bride's gown and we restaged the wedding and reshot it. We even got a cake. But you can't really do it over again.

Today the brides often don't want their picture taken. At a recent, big Bar Harbor wedding the bride and groom made a point of turning their backs on the camera. I finally said, "I know you fellows aren't interested in having pictures made, but it means something to your parents. All I ask is that you don't turn your backs on me. I'll do the rest." From then on things went smoothly.

I still come and look at the proofs of every wedding I do, but I don't keep any pictures.

Interview with Clement McLarty: Boston, Massachusetts

Photography is the only thing I ever wanted to do and I still try new things all the time. Even now it is my greatest ambition to be a really good photographer. All my photographic work is candid—even my studio work. I call a picture a candid if you take it without the person knowing exactly when you will take it. I recently gave up artificial light because it made people too self-conscious that their picture was being taken. I like to talk to people and get to know them and have them forget I'm taking a picture.

Young people want pictures the way they are. They don't want any fake or phony stuff inside or outside the studio. They want to sit on the floor and wear comfortable clothes. I often play music. They say, "Gee, Clem, I hate to leave." They are my friends by the time they leave.

Sometimes I think I shoot for me. There is certainly part of me in all the pictures I take. It is that certain feeling inside you that says Now's the time. It is something I see in you when I shoot you.

People are uptight in front of a camera. They say "I have a twisted nose and bad eyes." My technical thing is to get them to enjoy it and be alive. I have to like what I see to take the picture. It's a two way thing.

I prefer black and white. It is the way people are to my eyes. Color has less feeling in it and I don't like sending my work out to be processed.

I usually work until 2 A.M.

My greatest ambition is to have a show of my pictures that goes from ceiling to floor and from wall to wall. I'd walk in the room and know everybody there.

Interview with Orrion Barger: Chamberlain, South Dakota

I started taking pictures in high school in 1931, but I thought I wanted to be an artist and taught art in the public schools. I loved photography, though, and finally decided I wanted to express myself in photography rather than in art. I've been a photographer here in Chamberlain since 1941. I've never wanted to do anything else since.

The move from black and white to color has made me feel less a photographer. I almost feel ashamed—it's not nearly as creative—it's true. It's on my mind so much. I just don't feel nearly the photographer I did before. You can make black and white your own print and you can't do that with color. It all gets sent out and it doesn't seem right. I'm jealous. It's not truly yours. I used to work 16 to 18 hours a day and I loved it. It's getting less each year, but I used to love being alone in the evenings and no one bothering me—working in the darkroom. I just feel less a photographer now. That's what I mean.

The customer accepts more in color. They don't expect any correction work. I used to take wedding pictures of farmers in summer and they would be ghostly white from the top of their nose up and have a black lower face from the hot sun and working outside in hats. In color that seems to be O.K. with them, but in black and white we always had to even things up a bit.

People think I walk through taking wedding pictures like an old plow horse. Not so, I am not that calm. Time is one thing that keeps you from being relaxed. Things keep happening and they happen only once. It's a new event for each wedding couple. I take pictures by talking to people and that, too, takes a lot of you.

I think I know everybody in this town. Sometimes I know too much. I know what they can afford and what they can't and that can be difficult. But I also know what to avoid and what to bring out in the work. What they like and what they don't like. I'll get a divorced mother and dad in the same group for a picture when the couple said I could never do it. I probably took the parents' wedding pictures too. That happened to me at three weddings in one day this summer.

I don't think the future of professional photography is too great. It's been good to me, but now too many families are doing their own wedding pictures with all the new easy equipment. Politicians will always be photographed, but once a politician gets to Washington he's no longer your customer. Outside of institutional photography, portrait photography as we knew it in the past is gone.

The South Dakota joke for the photo of the wedding car (see page 103) is "Hot Springs tonight, Deadwood in the morning."

Interview with Martin Schweig: St. Louis, Missouri

My grandfather was a photographer in the last part of the nineteenth century, but most of his photographs were burned. My own father started to work about 1904. I started to help him when I was about fifteen, but I took pictures when I was on my first bird walk when I was about nine. Birds and photography still go together for me.

I prefer candids. In the studio everything is phony except the photographer. It is his world and the subject is at a disadvantage because it is the subject who has been taken out of his environment. I don't like artificial light either. You saw my father's and grandfather's pictures—even in the 1890s they were informal and taken in the home. Those pictures are the forerunners of today's candids. We just use smaller cameras. I remember my father carrying that enormous 8-by-10 view camera around St. Louis on a streetcar.

I don't know more about cameras than anybody else. Any success I have is because I can relate to people. I first recognized the skill required in taking wedding candids when I tried to hire someone to do it, and they couldn't. You must be on your toes and you must have the right timing and the final picture must be of human beings. A camera is like a paintbrush—no more.

I had one wedding where the groom, after a stag party, walked into the wrong hotel room and was beaten up. He ended up in the hospital with a concussion. A quiet little wedding took place at his bedside, but then the bride's parents went ahead and had this enormous society reception at their home. Do you know that no one missed the groom at all, and you don't even miss him in the pictures except in the wedding cake scene? I suppose the bride missed the groom, but no one else noticed he wasn't there.

The photographer has become part of the pageantry today. One woman asked me to take pictures as the bridesmaids came down the aisle. I resisted because I don't want to be intrusive, and you need flash with moving people in a church. It turned out she didn't care if I had film in the camera, she just wanted her guests to see the flashes.

The future for professional photography is dim. It costs too much to have a studio today. Only the millionaire will be a free soul in photography and he will take pictures for himself and will not do weddings. Costs of owning a studio have gone up and there are too many photographers. It is the end of an era. Photographers will have to be tied in with a corporation. The day of the independent studio is over. We now have self-loading cameras, self-taking exposures and self-loading weddings.

Photography will join the rest of the arts finally and you will have to teach to make a living.

Interview with Frank Ferrario: Partner in Martin Schweig Studio

I joined Martin right after the war. I thought I wanted to be an artist, but then I decided I would rather be a photographer.

The formal studio work bores me. It is embalming a person—wrinkles are out, hair is put in, teeth and even neckties are straightened.

Most men do not want to pose. They avoid it. What man wants to be in a tux and go to an afternoon party—even if it is his own wedding. No wonder they look stiff and uncomfortable. It is the bride's thing.

Interview with Samuel Cooper: Brookline, Massachusetts

I took my first picture when I was about eleven. I loved it. I saw a picture come up in a tray once and I've been hooked ever since. I just kept coming back to it until I became a photographer. When I started I photographed all the kids in the neighborhood and anyone I could get to pose. I didn't charge. Then I began to charge for materials, and then it began to pyramid and I was a photographer.

When I first started I worked out of my house and I had no equipment and just a tiny darkroom. I often found myself working until two or three in the morning and I'd often fall asleep working. I was a one-man-operation and it is a trade with long hours.

We went into candids after the guests started taking their own candids and asked us to do likewise. It was in the early forties. With understanding I found no difficulty switching back and forth between taking formal portraits and candids. Candids are like good snapshooting and they are an opportunity for free artistic expression for both you and the subject. It is what is happening—a kid running, kicking a football. Inside the studio both you and the sitter are harnessed and you express yourself by playing with light.

I find black-and-white photography more challenging because the lighting is more important. In color you can just flash and color takes care of the modeling of the face.

My great-grandfather started the business in 1912 and my grandfather started about 1925, but he had worked for his dad from the time he was ten. As for me, I've been helping out since I was five and taking candids since I was twelve. I started out holding the lights and doing what I was told and watching and copying my grandfather. I don't agree with all of his advice anymore.

It was so much in the family and I just carried on the photographic tradition. When I was really little I turned on the lights and ruined all the prints in the darkroom. I learned.

We had one case where the couple got into a bad fight and tore up their pictures, and then when they made up we had to reprint every one. Sometimes they don't admit what happened. One large 16-by-20-inch oil portrait was brought in with unmistakable deliberate gouges in it all over and they said it fell off a wall. We did that over again too.

Professional photography is going down the drain because there are too many amateurs in the business. They skimp on wedding pictures and that's the last place to skimp. You can't have a wedding over. A bride came in here crying because her wedding pictures didn't come out—a whole wedding of feet and no heads. So he rented a tux and she pressed her dress and we got a great studio portrait. But they will always miss all those pictures of what really happened.

A Brief and Highly Speculative History of Wedding Photography in America: Based on Pictures Found in Attics, Basements, Professional Photographers' Negative Files, Historical Societies; and Interviews

1839 to 1870

Unless some forgotten superstition once led to a massive destruction of wedding photographs, very few people had wedding pictures taken during photography's first thirty years. In the early 1850s there were sixty-five daguerreotype portrait galleries in New York City alone. Thousands of these portraits have survived, but almost no wedding portraits. In the late 1850s the durable, inexpensive, folk art tintype and the sturdy little *carte de visites,* carefully preserved in special albums, replaced the expensive daguerreotype. Searches in private homes and public collections have unearthed thousands of these portraits taken before marriage, after marriage and of the couples and their children; but wedding pictures are a rarity. Was the magic of transferring a person onto a two-dimensional surface enough of an event in itself that one did not need another reason for doing it? Perhaps the taboo about being seen in a wedding dress before the ceremony prevented the photographer from taking his picture before the wedding; after the wedding the bride was too busy for the long sitting required to do a fine portrait.

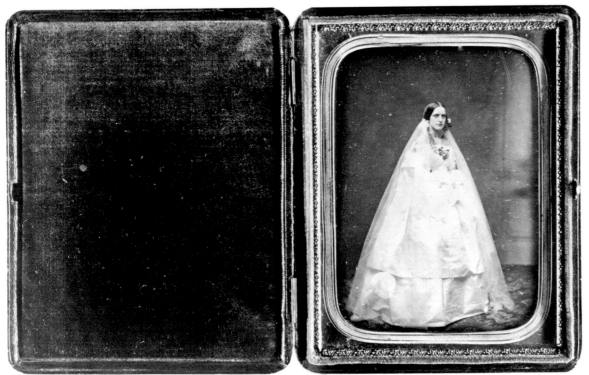

Photographer unknown
Daguerreotype
c. 1850
Lent by Ernest Morrell

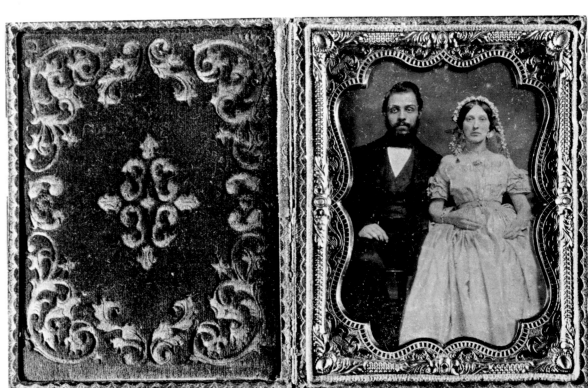

Photographer unknown
Tinted ambrotype
c. 1860s
Lent by Temple Bar Bookstore

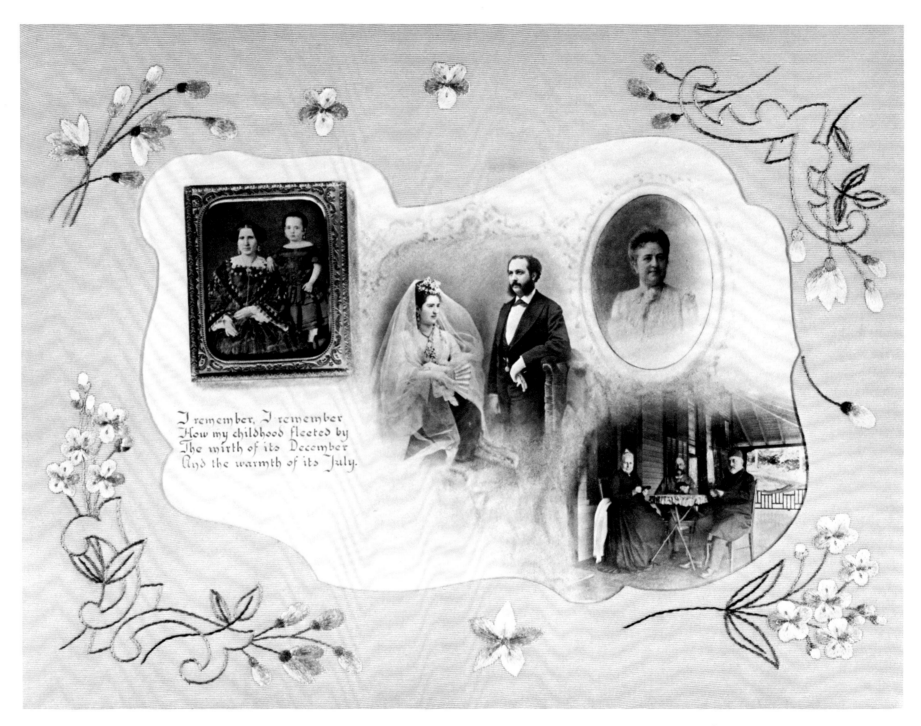

I remember, I remember
How my childhood fleeted by
The mirth of its December
And the warmth of its July.

Photographer unknown
Golden Anniversary Album printed 1905
Wedding picture 1855
Lent by Mrs. Ashton Sanborn

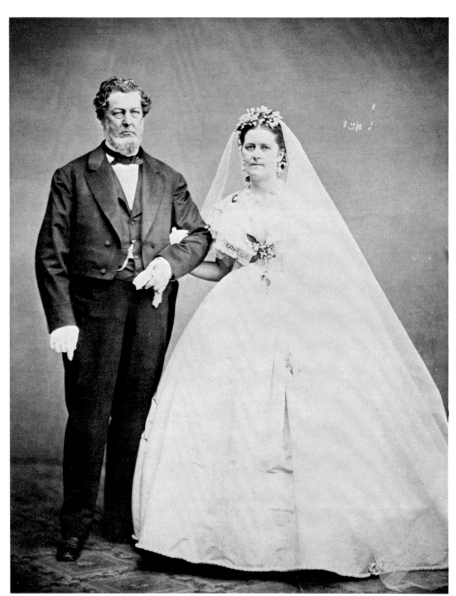

Photographer unknown
Harvard Imperial Portrait Collection
c. 1860s

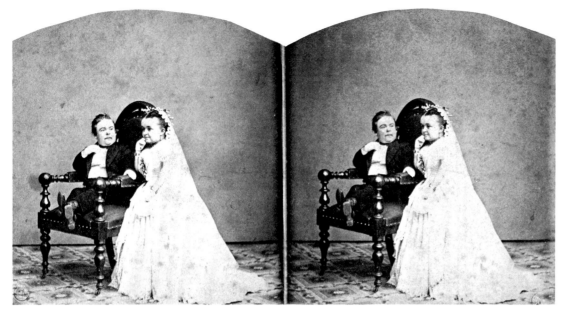

Brady Studio
Tom Thumb: The Fairy Couple
Studio views
1863
Lent by Richard Russack

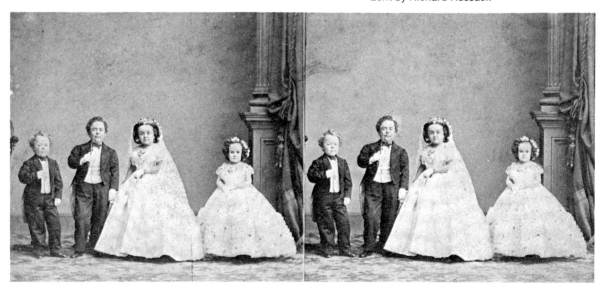

After 1870 wedding pictures show up with increasing frequency. Wealthy couples began to hire photographers to make portraits of the bride and groom together, often set in the home, where the couple is surrounded by the props of Victorian stability and opulence. By the turn of the century group portraits of family and wedding parties were added to the wedding record. The photographs were taken with beautiful wooden studio cameras which used 8-by-10-inch negatives. The stands were elaborate and ornate. When the photographer moved into the home of his subject he used portable equipment, although many kept the large negative. Couples with less to spend went to the local studio to record their weddings in 4-by-5½-inch photographs (called cabinet photographs). The studios assembled fake background sets, imitating the architectural fashions of the wealthier class. In the early days of photography these props included the columns, arches, ornately carved chairs, and Grecian urns reflecting the period of classical revival in America. Imitating the earliest *cartes de visites,* wedding photographs were full length, recording the bride resplendent in her wedding gown.

Around 1880 the stark eye-to-eye portrait was joined by the pose of the demure bride with bowed head and lowered eyes turned away from the camera. This virginal pose, which transforms the bride into a still life, remains popular today. The oblique portrait of the bride looking into a mirror, where the viewer has eye contact with the mirror image rather than with the bride herself was another addition. A few charcoal-tinted and greatly enlarged prints began to appear in the 1880s. These formally posed portraits were printed from negatives retouched to display a person more perfect than the subject. Hair styles, the kind of props used by the studio, and the kind of paper and toning or tinting change with time, but presentation of self (feminine, beautiful, demure, soft, radiant, serious, serene, innocent and dignified) is unchanging. Formal wedding photography reflected little of the social change brought on by the industrialization, urbanization and immigration that swept America during this period.

Stereoviews were made of posed informal shots of celebrities and wealthy people as early as the 1860s and by the turn of the century there were hundreds of comic, posed candid stereos which emphasized the mishaps of marriage—henpecked husbands, cheating wives and fights with rolling pins.

Percy Byron, along with a few other outstanding photographers, made outdoor candid wedding shots and posed informal indoor pictures beginning in the late 1880s.

By 1900 the new technology of reproducing photographs allowed magazines and newspapers to use photographs to illustrate their articles, and weddings were news. But the photojournalist had a vision of getting married quite different from the studio photographer's. He was interested in the bizarre, the celebrity and in gossip. His photographs tended to show the tensions and cracks in our norms and values rather than our traditions. However, the force of the ceremony often prevails and nudists still wear veils, surfboard-riding brides wear wedding gowns. At a much later date homosexuals want the structure and rituals of a marriage ceremony; and young people creating their own ceremonies still invite all of their families and friends.

A few art photographers began to use the wedding as subject during this period. But weddings never became a popular subject for them. Art photographers are interested in self-expression more than in subject matter, and self-expression may prove difficult with a ceremony so primeval. When they do take photographs of weddings they often fragment people, seek out ironic settings such as marriage marts in Las Vegas or emphasize the sadder aspects—a young couple facing an uncharted future cut off from family and friends.

Studio photographers ignored these innovations and continued their traditional portrait work emphasizing frontal, direct shots with the individual placed in the center of the frame. Shortly before World War I portraits showing only the head and shoulders began to appear. After the war many studios experimented with oil painting and enlarging the portraits.

In the 1930s amateur photographers began to use the improved 35 mm. cameras and, increasingly, weddings have been photographed by close friends of the bride and groom rather than by the studio photographer. The snapshots of the hobbyist have the intimacy and informality that comes from a warm interaction with friends, and the accidents arising from a lack of technical skills. Like the studio photographer, the amateur is making a record of an important event for the people involved.

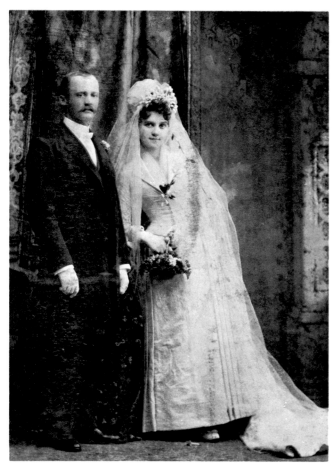

Hassall Studio
Keokuk, IA
c. 1870s
Lent by Roger Kingston

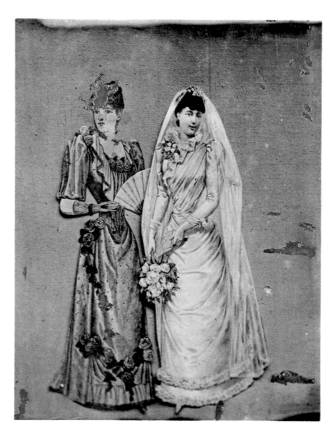

Photographer unknown
Tintype of a drawing
c. 1880s
Lent by John Howland

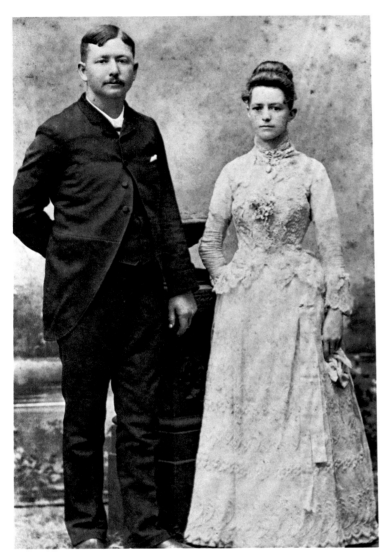

Family Album
Cabinet wedding photograph
Gaites Studio
Macomb, IL
c. 1880s
Lent by Roger Kingston

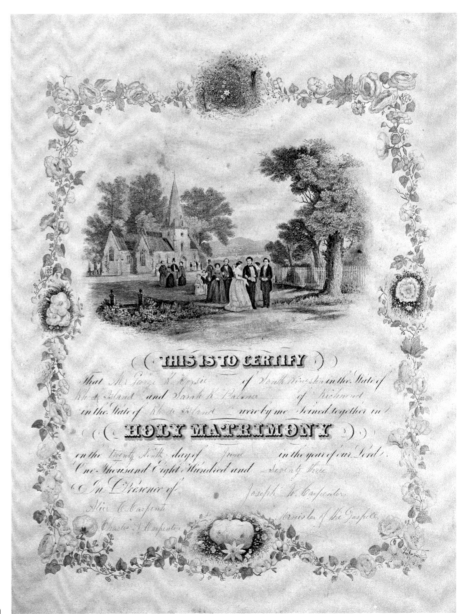

THIS IS TO CERTIFY

HOLY MATRIMONY

Wedding Contract
Rhode Island
1873
Lent by Adrienne Linden

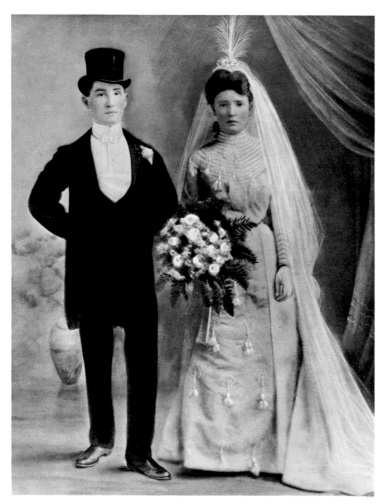

Photographer unknown
Pastel tinted photograph
c. 1880s
Lent by Tom Oakley

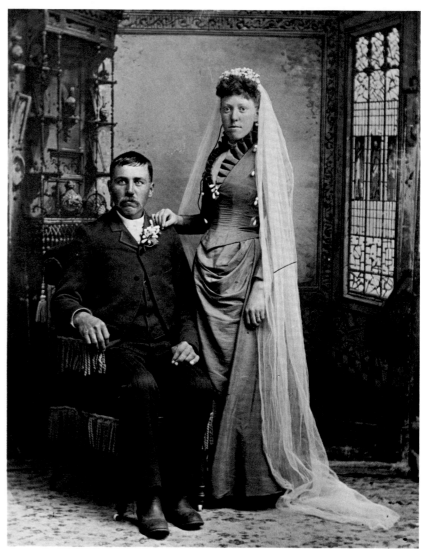

C.J. Van Schaick Collection
Madison, WI
The State Historical Society of Wisconsin
c. 1885

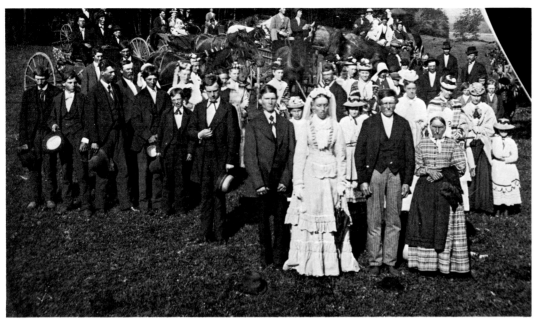

Andrew Dahl Collection
Madison, WI
The State Historical Society of Wisconsin
c. 1873

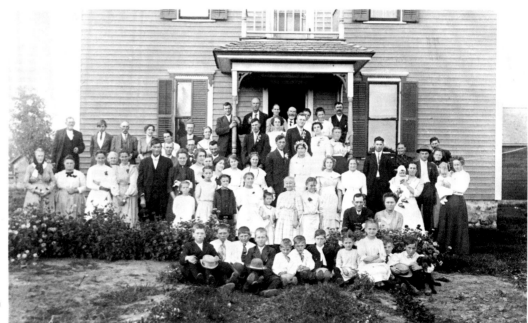

C. J. Van Schaick Collection
Madison, WI
The State Historical Society of Wisconsin
no date

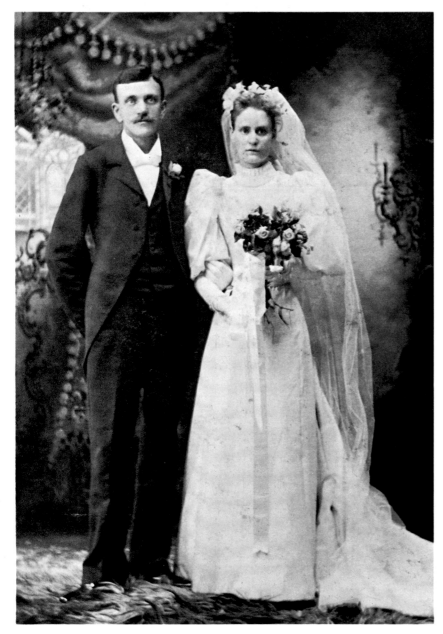

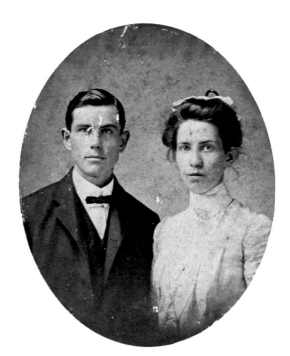

Photographer unknown
1890
Lent by Adrienne Linden

Family Album
Cabinet wedding photograph
Wales Studio
Keokuk, IA
c. 1890s
Lent by Robert Anderson

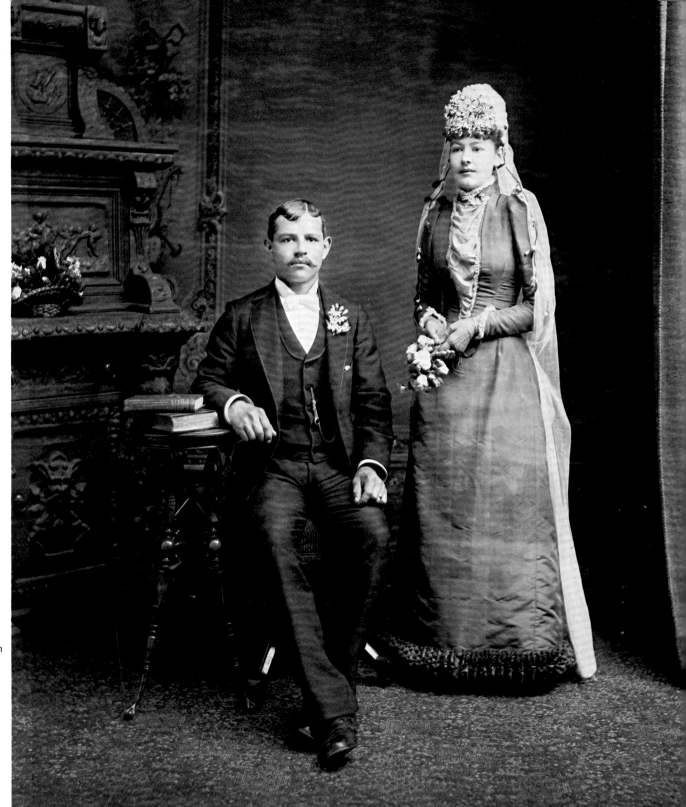

Photographer unknown
Wisconsin
1890

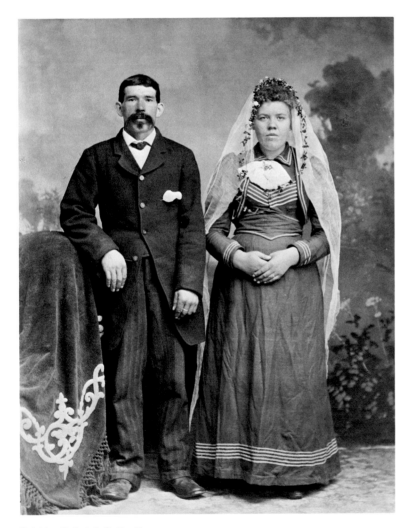

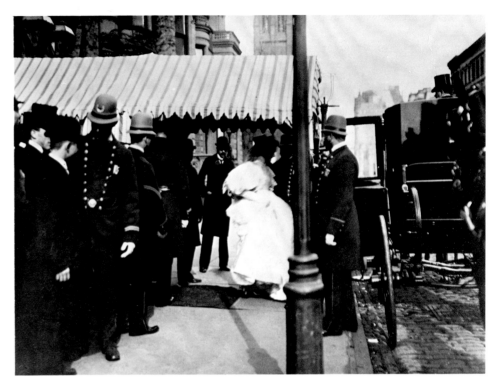

Percy Byron
New York, NY
The Museum of the City of New York
1895

C.J. Van Schaick Collection
Madison, WI
The State Historical Society of Wisconsin
1895

Percy Byron
New York, NY
The Museum of the City of New York
1899

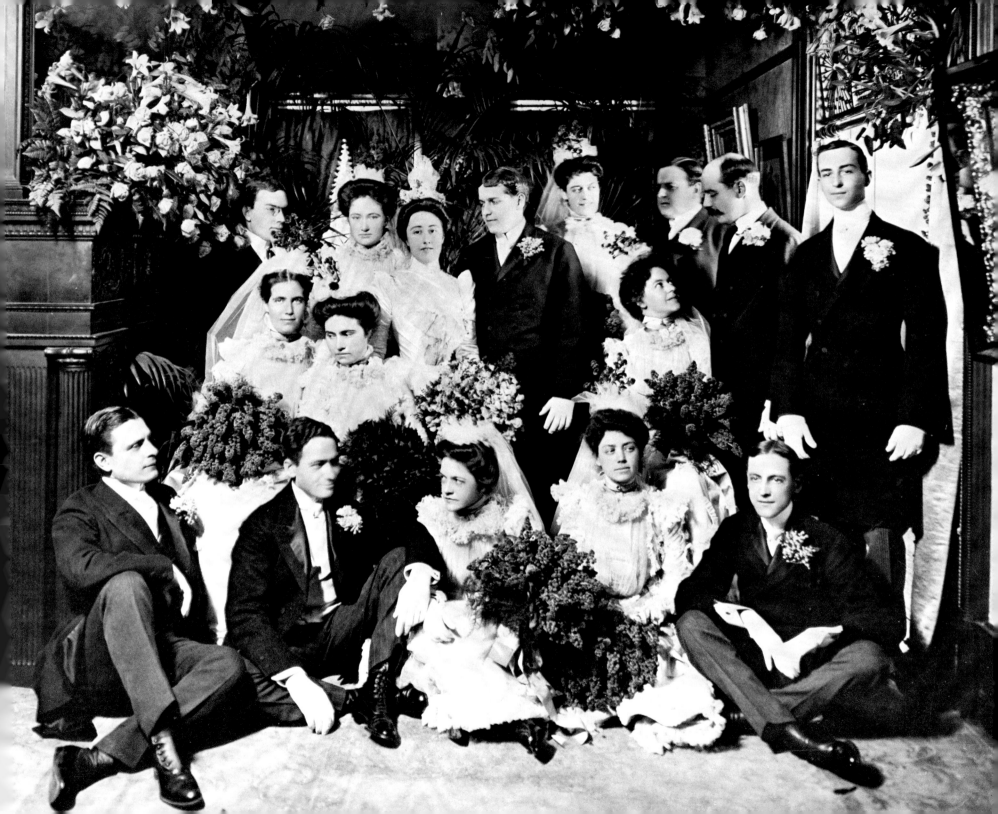

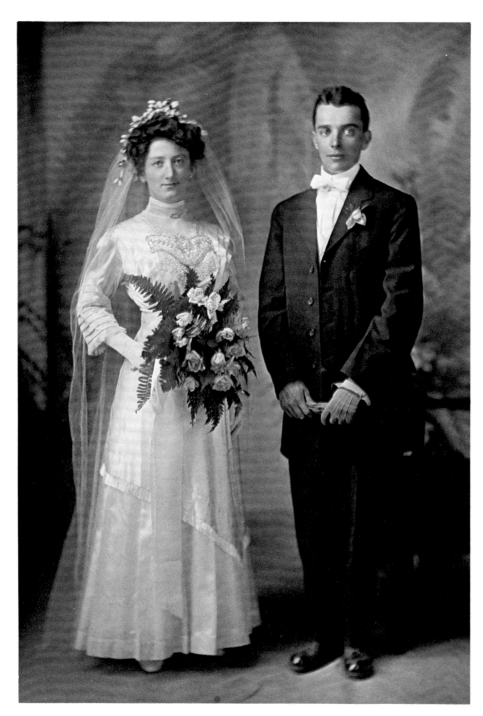

Goulard Studio
New Bedford, MA
c. 1880s
Lent by Barbara Norfleet

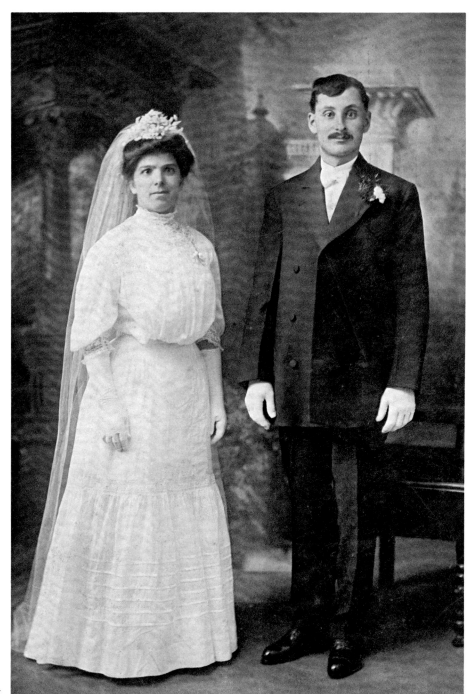

Goulard Studio
New Bedford, MA
c. 1900
Lent by Barbara Norfleet

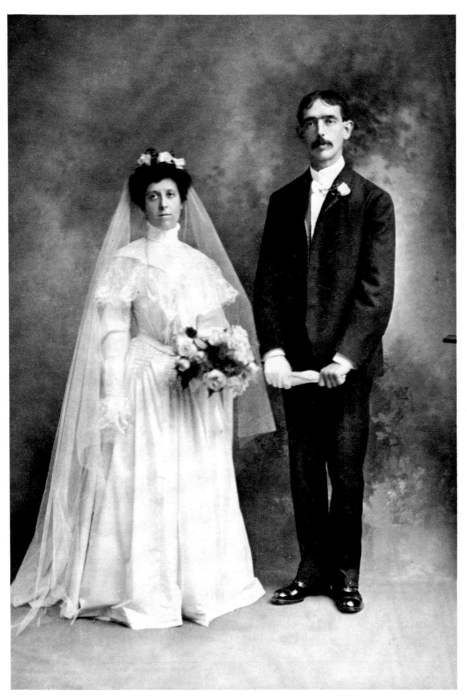

Goulard Studio
New Bedford, MA
c. 1902
Lent by Barbara Norfleet

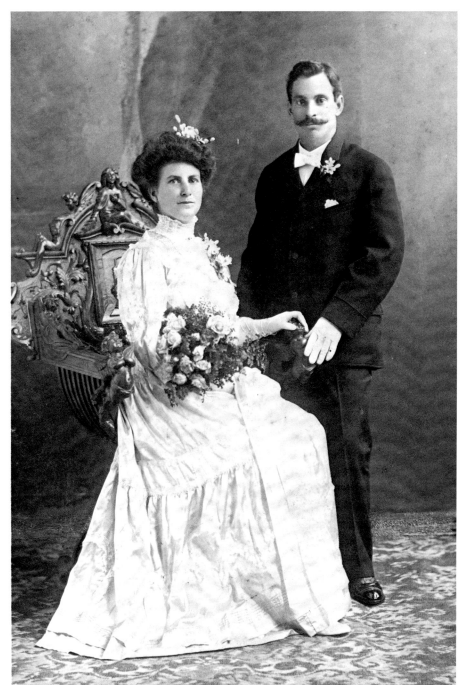

Logemann's Studio
San Francisco, CA
c. 1907
Lent by Barbara Norfleet

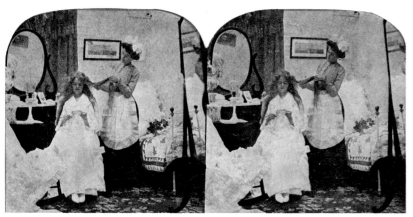

1015. The Bride in Her Boudoir.

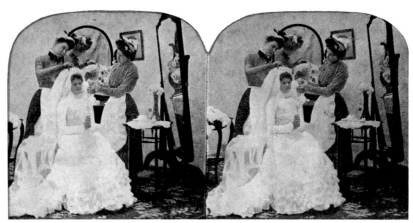

1016. Dressing the Bride.

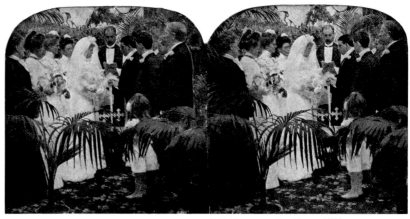

1017. I Pronounce You Man and Wife.

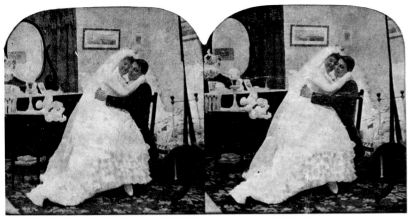

1020. When the Lights Are Dim and Low.

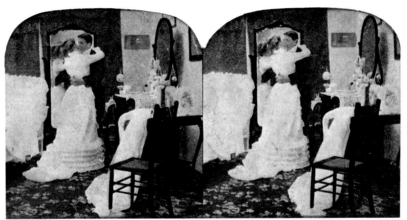

1021. One Heart's Enough for Me.

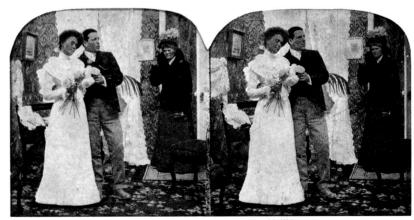

1023. Heavens! My Wife.

Photographer unknown
Tinted stereoviews reproduced in black and white
c. 1890s
Lent by Joseph Steinmetz

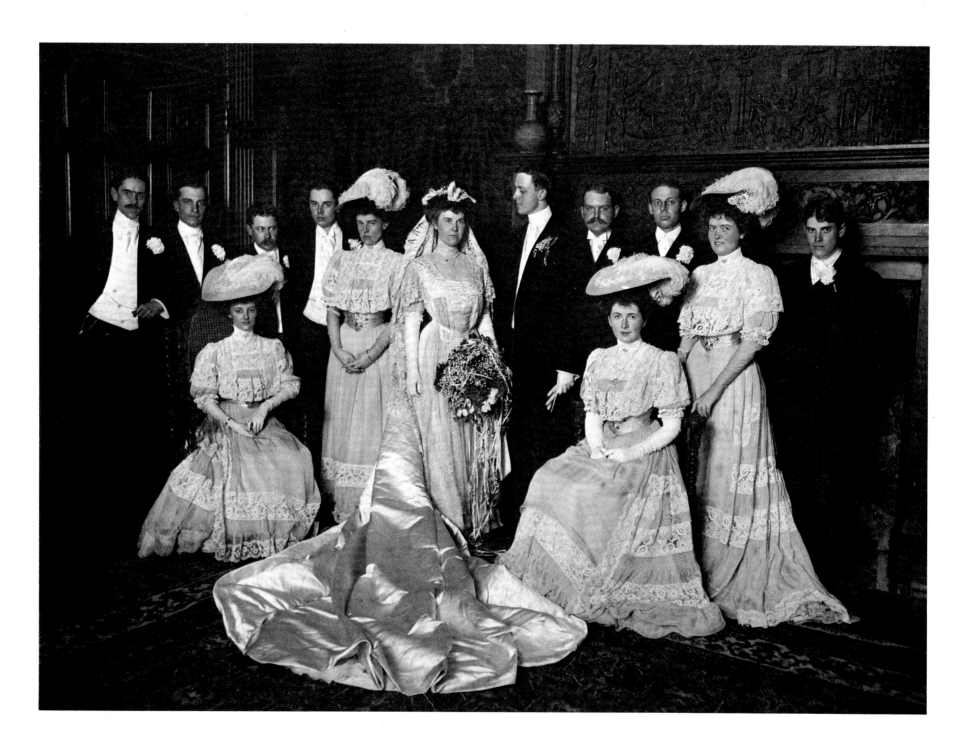

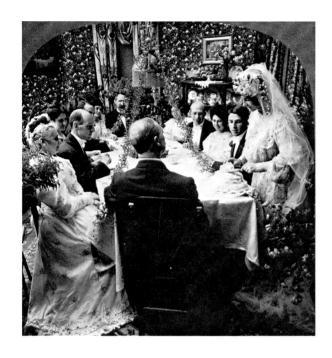

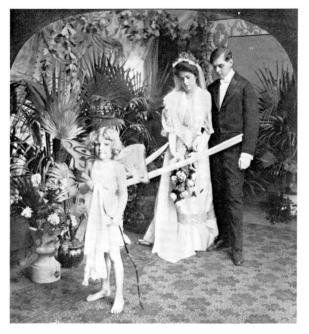

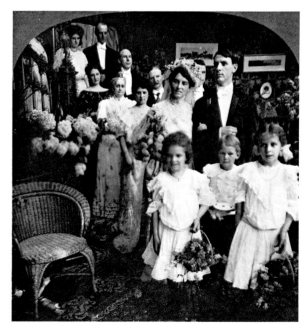

Alman Studio
Newport, RI
1900
Lent by Richard Rodgers

Photographer unknown
Three enlarged stereoviews
Library of Congress
c. 1900s

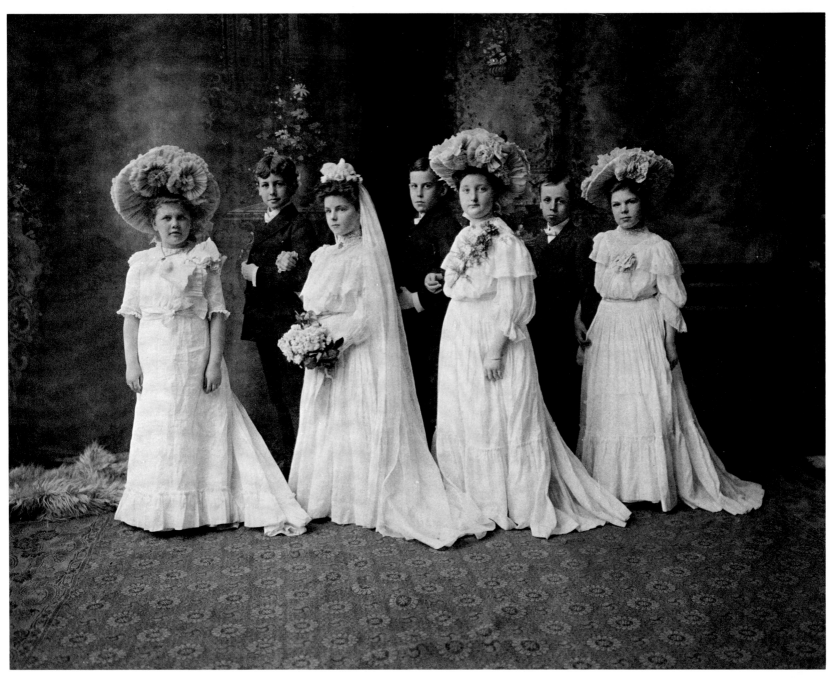

Photographer unknown
c. 1900s
Lent by Barbara Norfleet

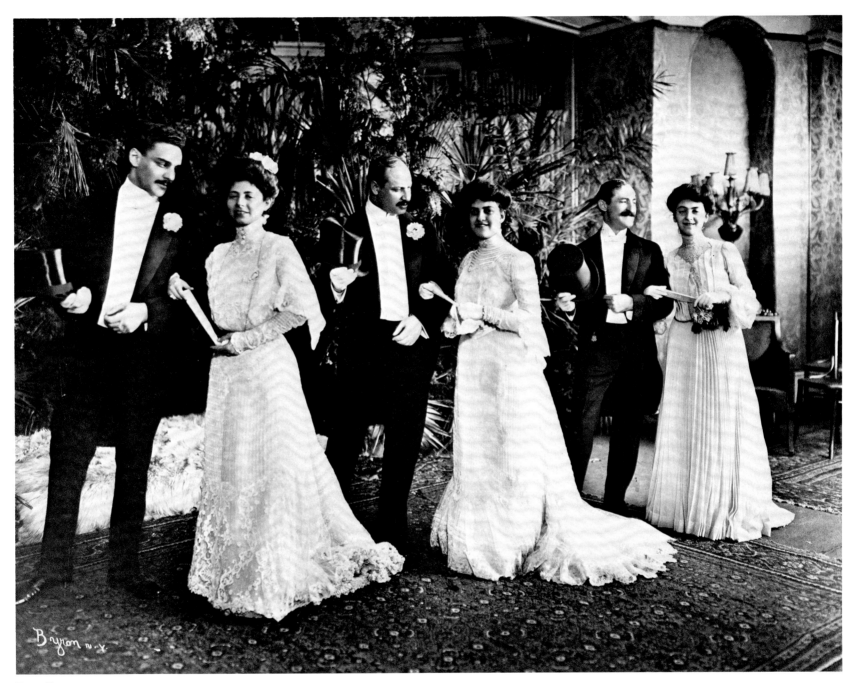

Percy Byron
New York, NY
The Museum of the City of New York
1903

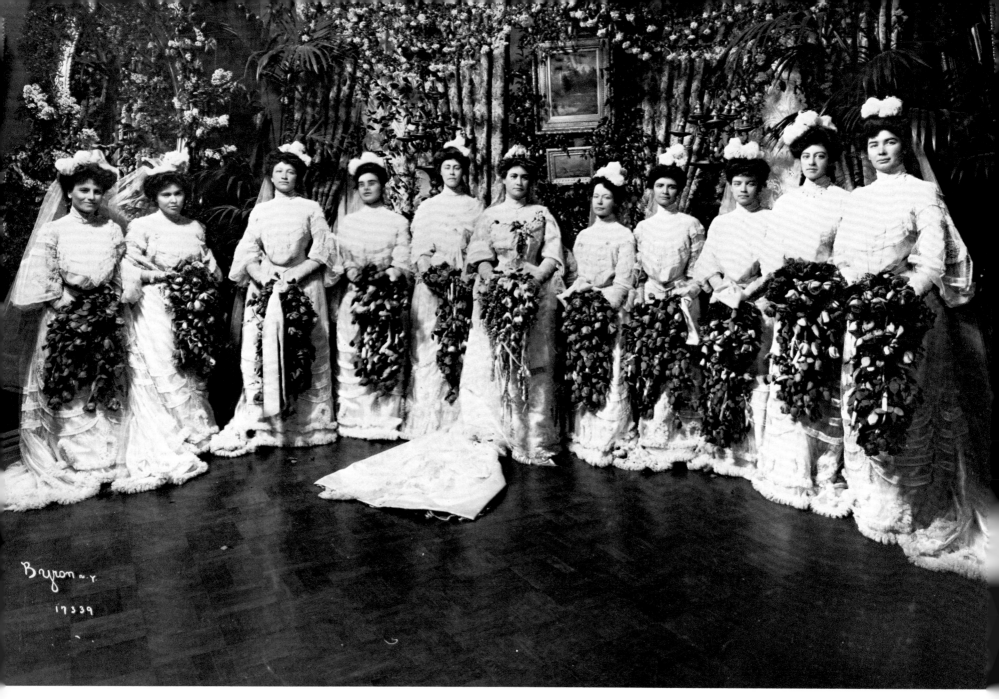

Byron ~.Y.
17339

Percy Byron
New York, NY
The Museum of the City of New York
1904

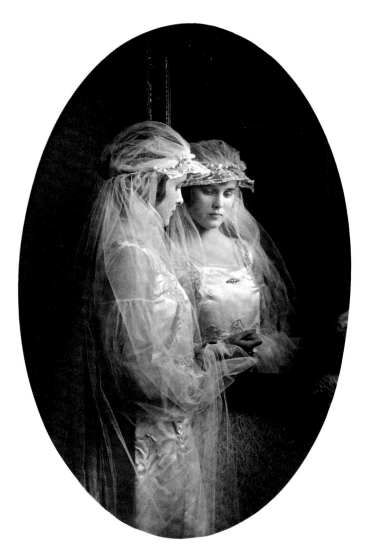

Martin Schweig Studio
St. Louis, MO
1911

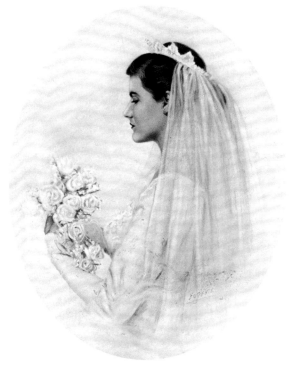

Eugenie Ragan
Porcelain miniature reproduced in black and white
New Orleans, LA
no date

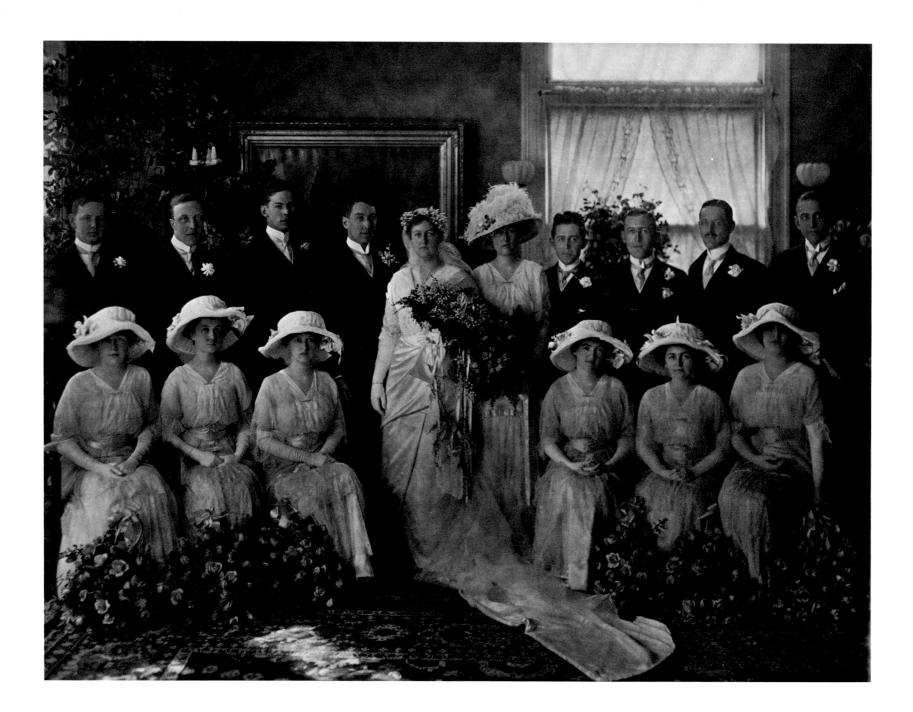

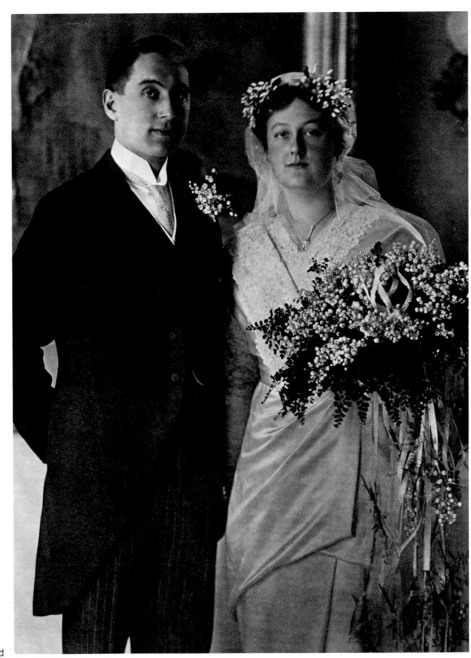

Bachrach Studio
Boston, MA
1913
Lent by Stephen Baird

Bachrach Studio
Boston, MA
1913
Lent by Stephen Baird

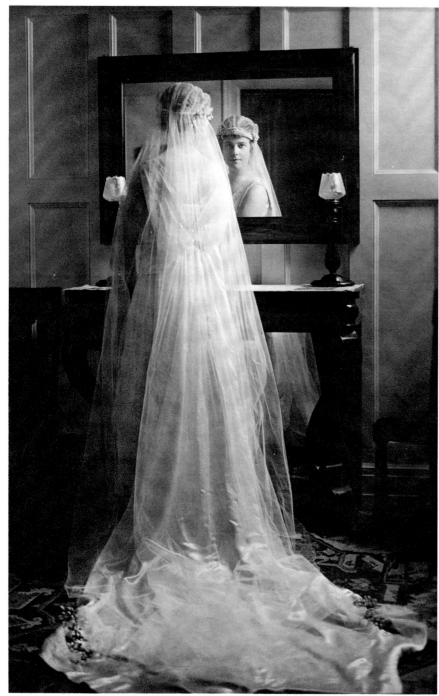

Martin Schweig Studio
St. Louis, MO
1916

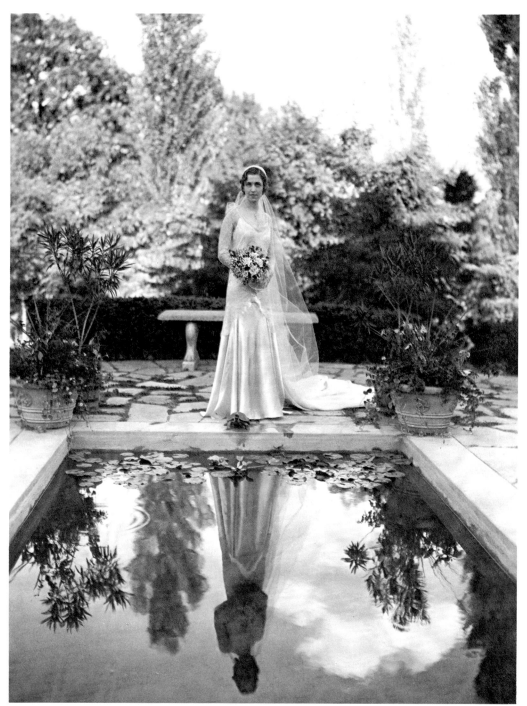

Martin Schweig Studio
St. Louis, MO
no date

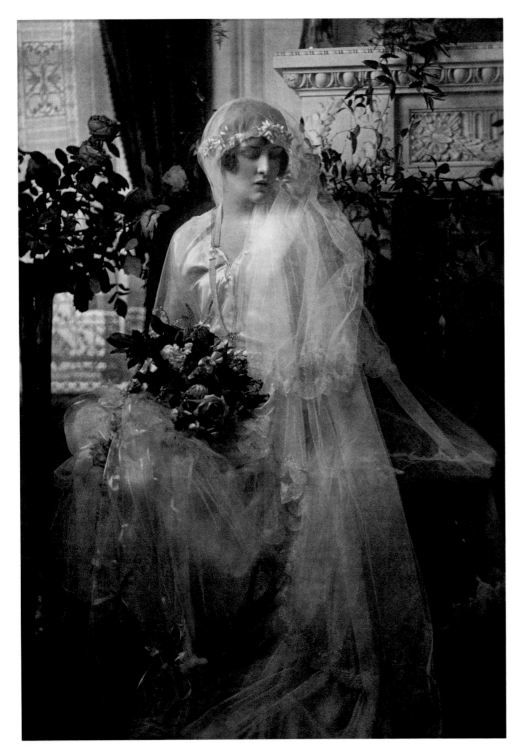

Martin Schweig Studio
St. Louis, MO
c. 1913

James Van der Zee
New York, NY
The James Van der Zee Institute
1920

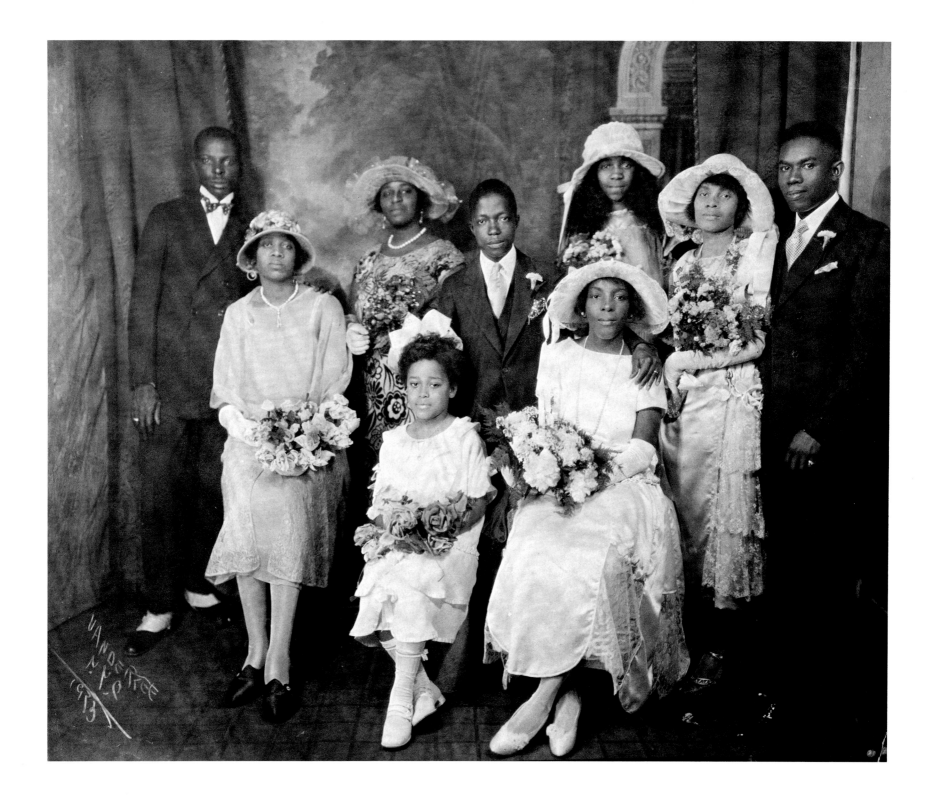

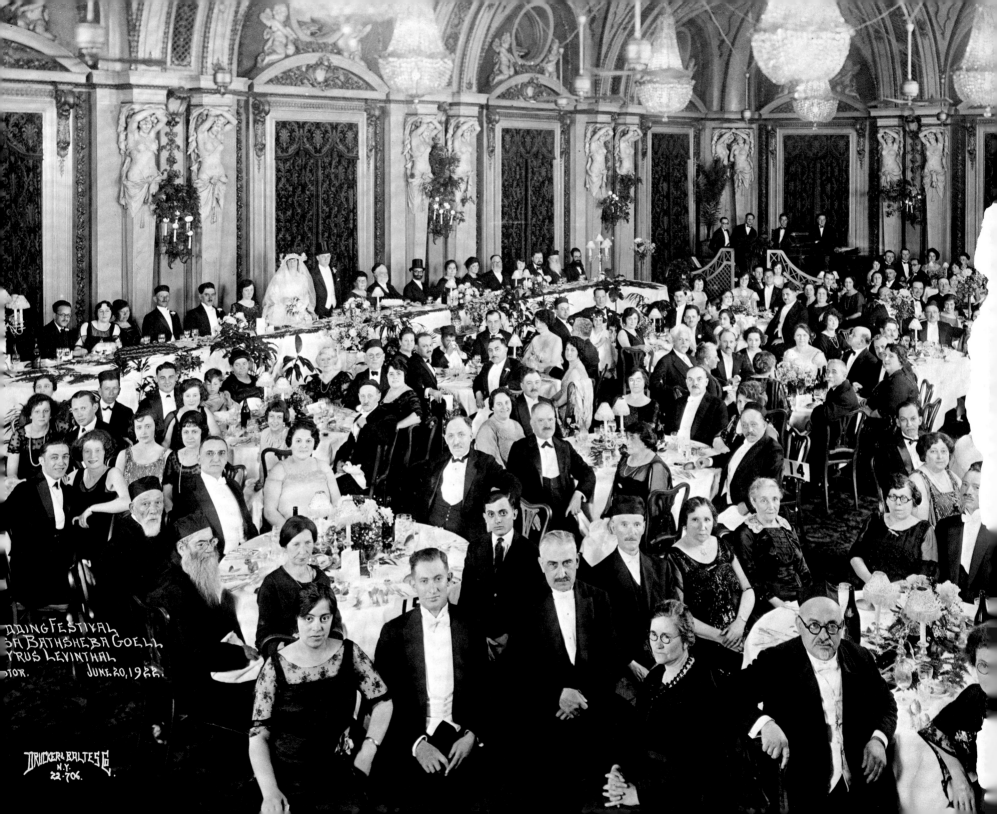

WEDDING FESTIVAL
...A BATHSHEBA GOELL
...YRUS LEVINTHAL
...TOR. JUNE 20, 1922.

DRUCKER & BALTES
N.Y.
22-706.

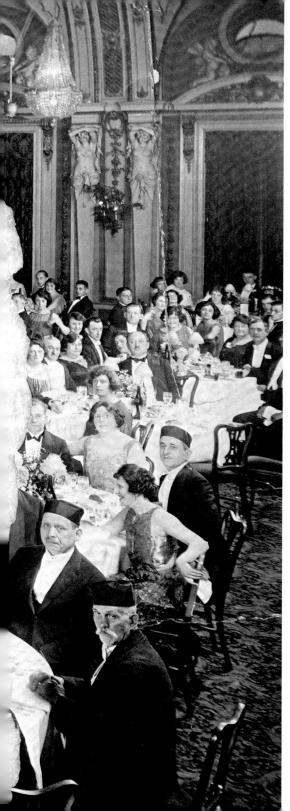

Baltes Company
Hotel Astor, New York, NY
Taken with banquet camera
1922
Lent by Jonathan Goell

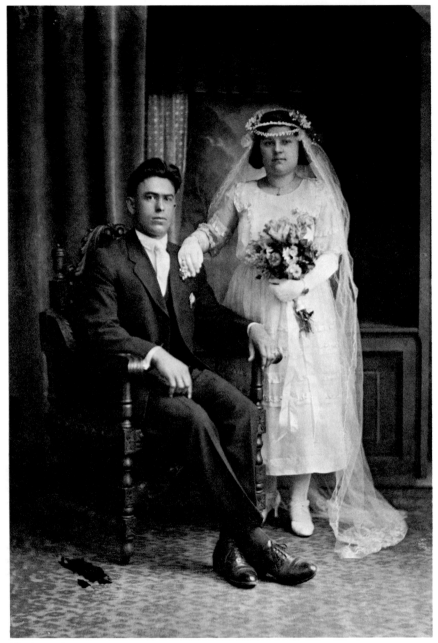

Photographer unknown
c. 1920
Lent by Alice Hall

Martin Schweig Studio
St. Louis, MO
c. 1920s

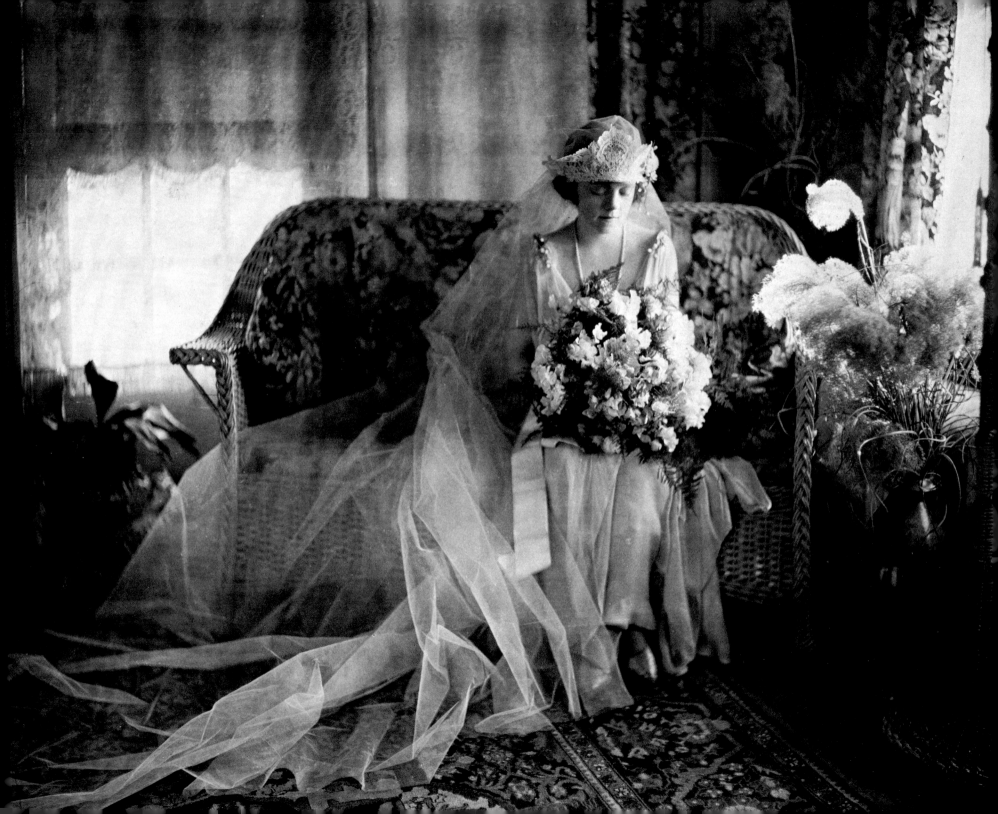

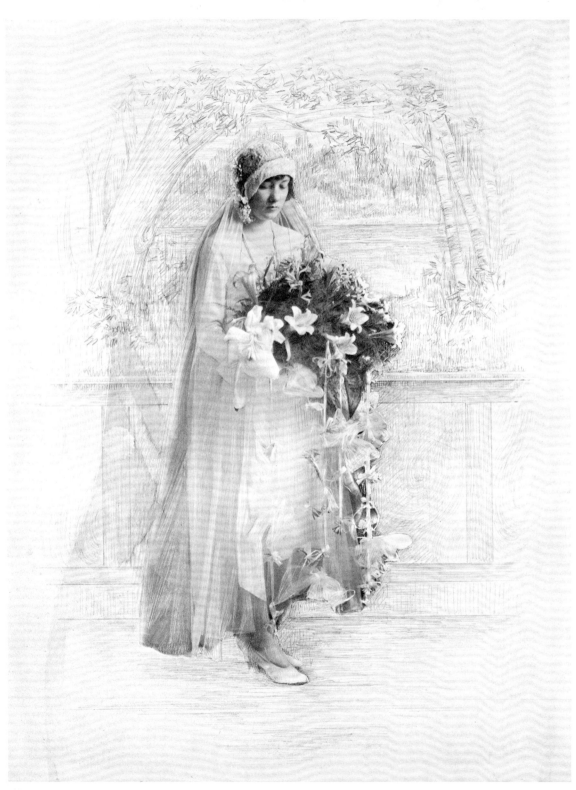

Martin Schweig Studio
St. Louis, MO
c. 1920s

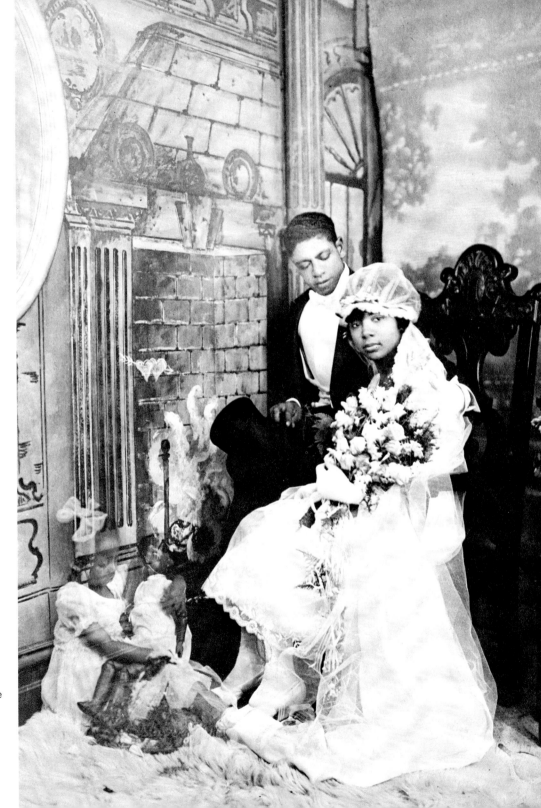

James Van der Zee
New York, NY
The James Van der Zee Institute
c. 1920s

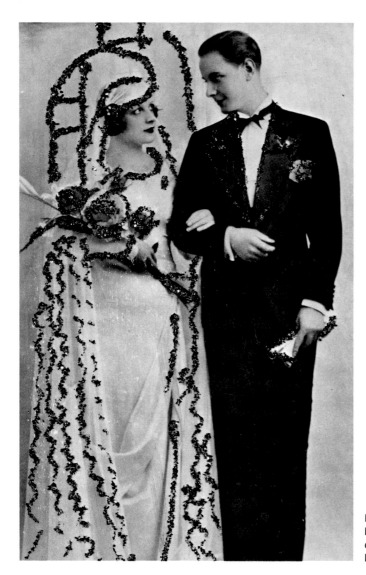

Photographer unknown
Postcard
c. 1920s
Lent by Bobbi Carrey

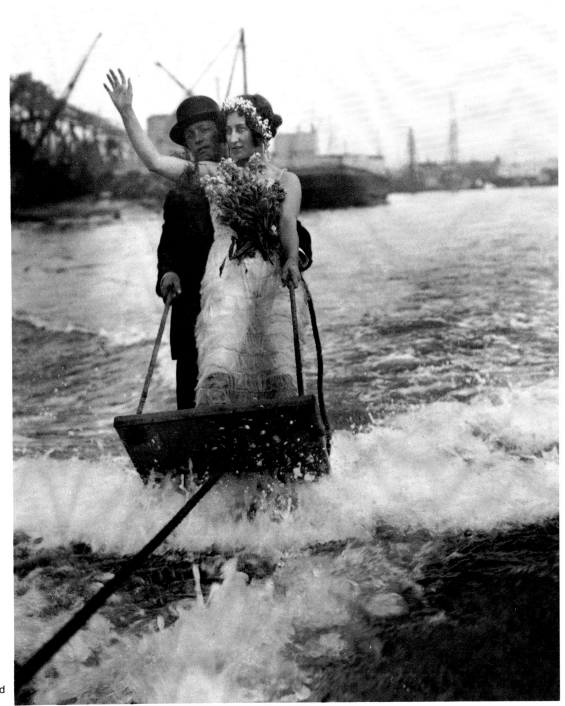

Unknown photojournalist
New York Harbor, NY
Underwood and Underwood
1927

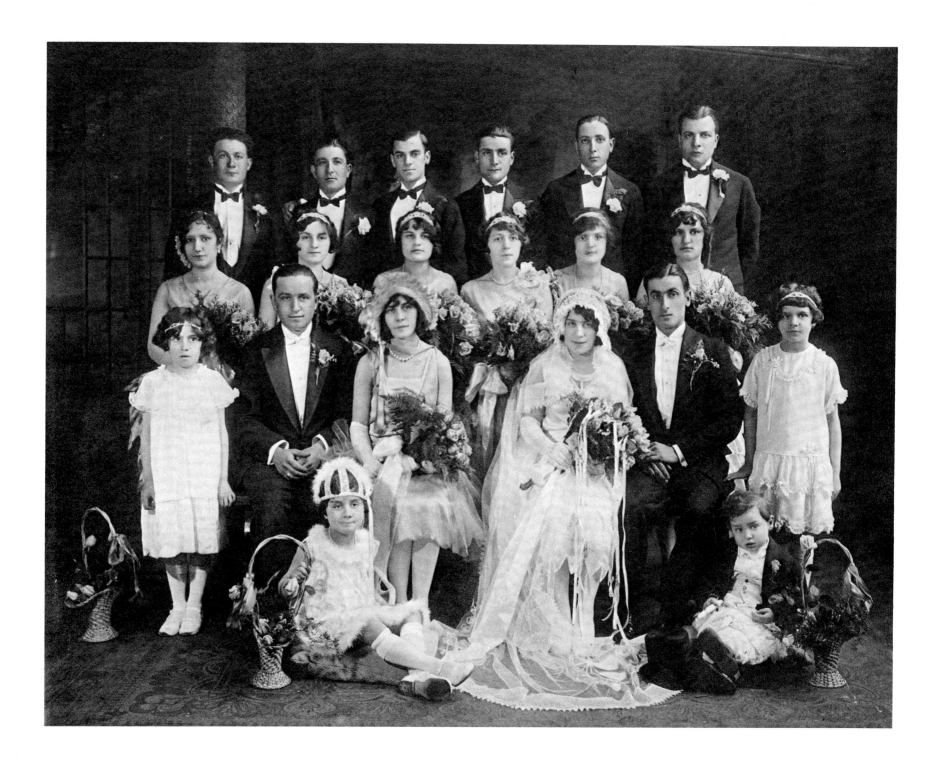

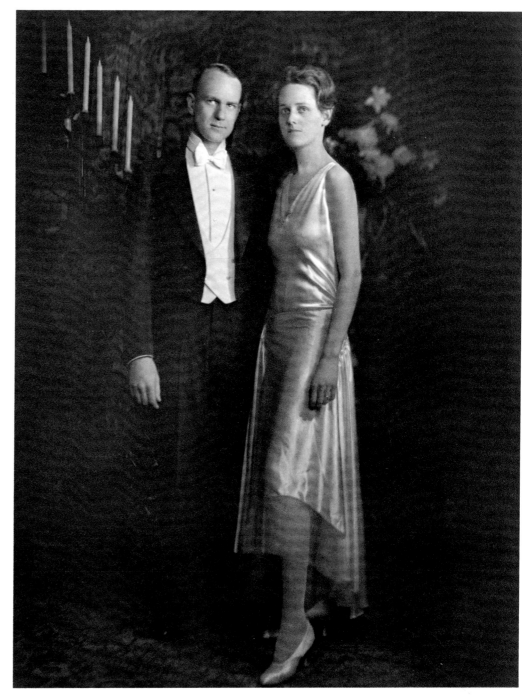

Fine Art Studio
Ossining, NY
1928
Lent by Tom Koloski

Bachrach Studio
Cincinnati, OH
1929
Lent by Chase Shafer

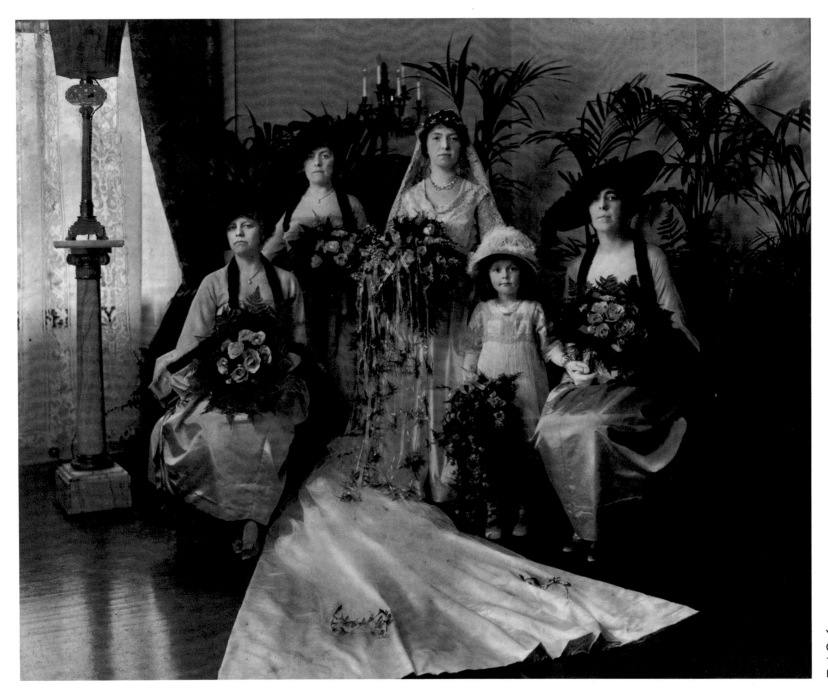

Young and Carl Studio
Ohio
1930
Lent by Richard Rogers

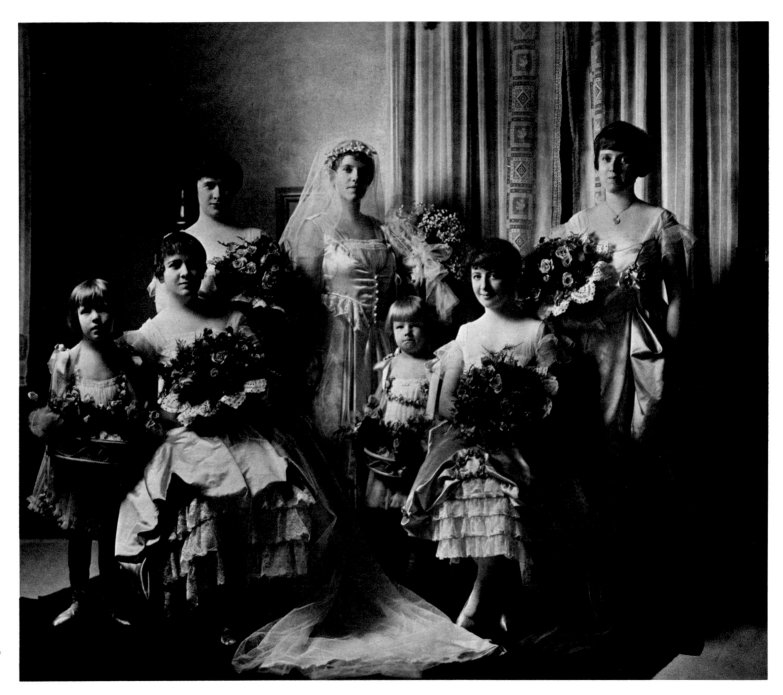

Martin Schweig Studio
St. Louis, MO
no date

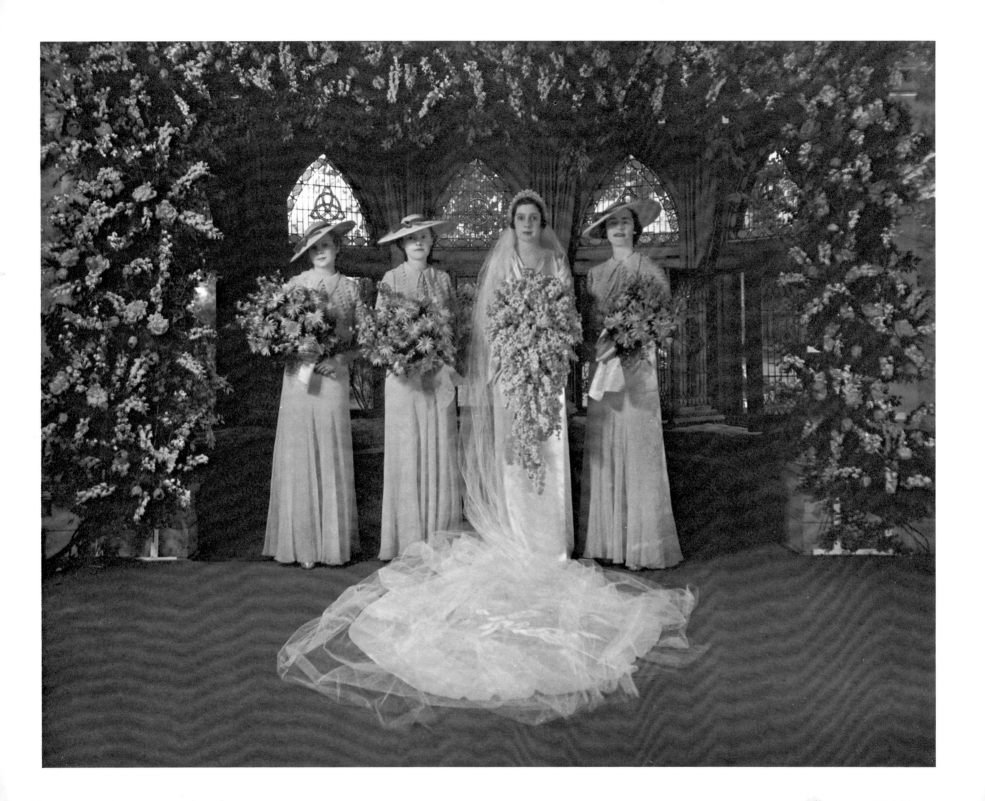

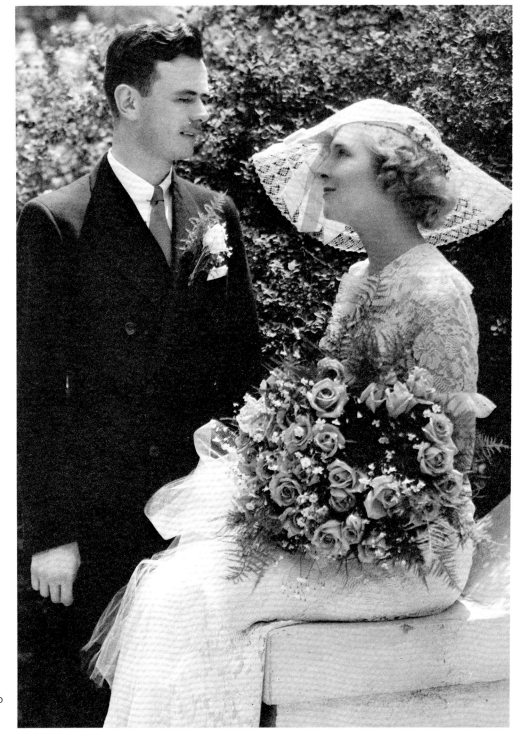

Martin Schweig Studio
St. Louis, MO
no date

Martin Schweig Studio
St. Louis, MO
1930

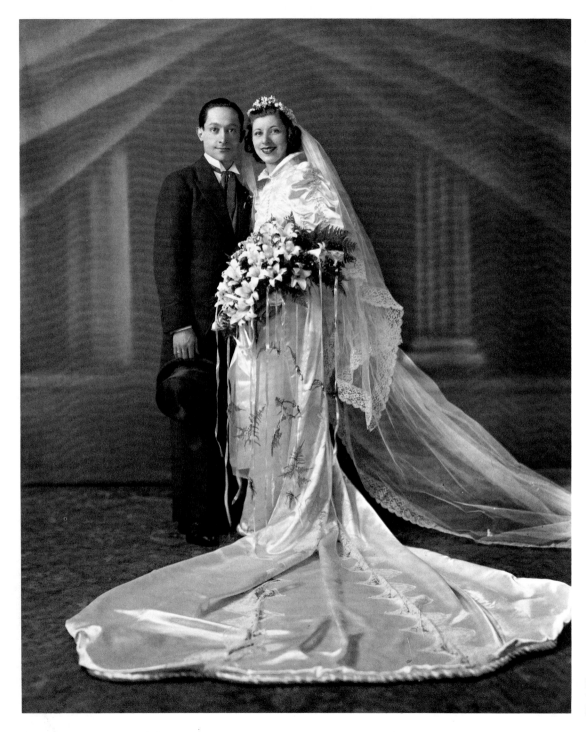

Paulette Studio
1939
Lent by Adrienne Linden

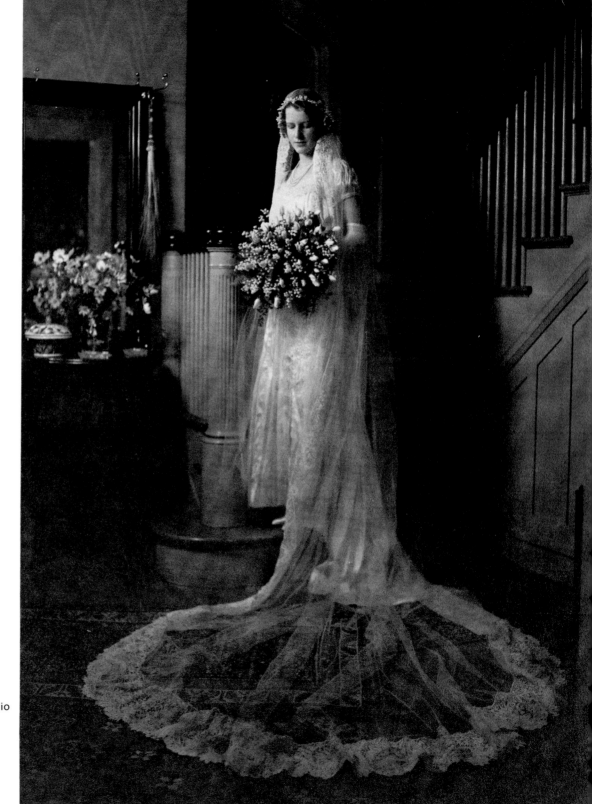

Martin Schweig Studio
St. Louis, MO
no date

1940 to 1965

Formal portraits continued to imitate portraits done by artists and to be taken with large, stand-mounted cameras, but about 1940 a radically new and different record of marriage emerged with the introduction of the candid. Candids were usually taken using the press photographer's Speed Graphic camera with its 4-by-5-inch negative. Photography could now do what painting could not: it could record the spontaneity of life, the private moment. A special album of wedding pictures became common and wedding photography became the principal activity of the studio photographer. The photographer captured the fragmented acts of the wedding day: he moved, camera in hand, from bedroom to church to reception to departure. There were always a few stock shots, but the best photographers developed a great ability to recognize an opportunity for an original view of the wedding scene. The candid prints are made from sharp, unretouched negatives, and they depict in fine detail the customs of getting married in America. They have much in common with documentary photography, although the people portrayed are usually part of the middle or upper classes rather than the poor or oppressed.

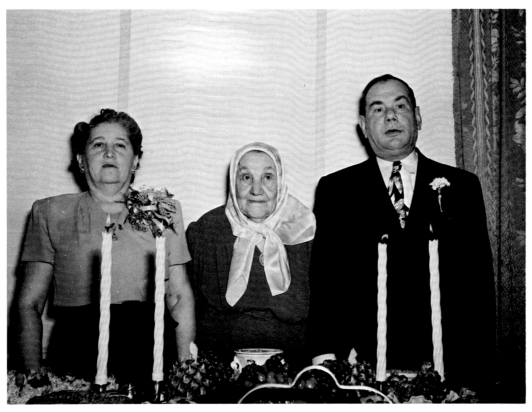

Samuel Cooper Studio
Brookline, MA
1940

Samuel Cooper Studio
Brookline, MA
1940

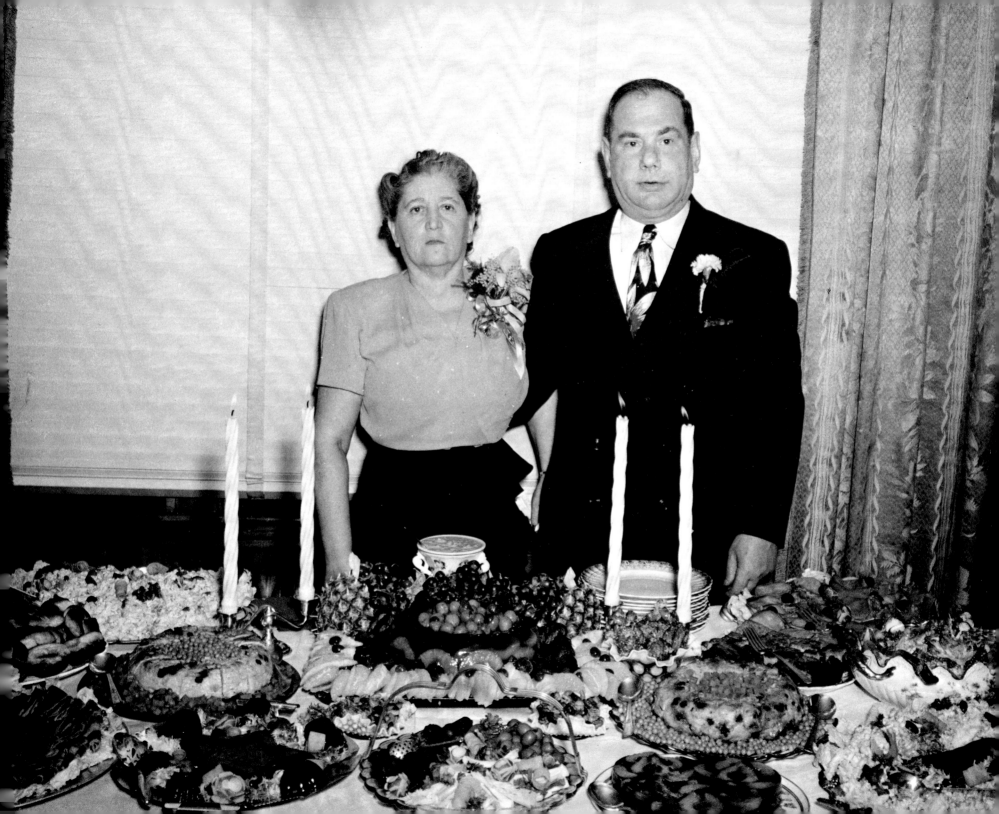

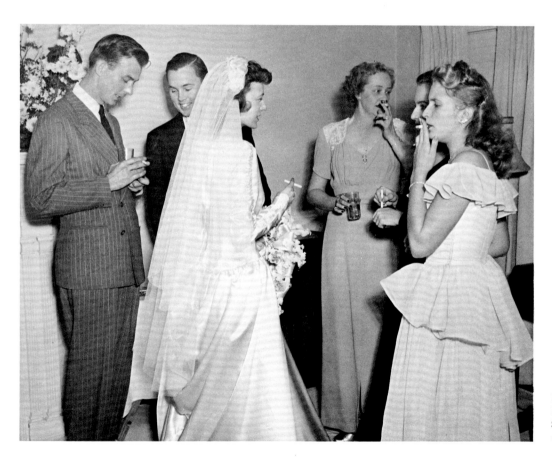

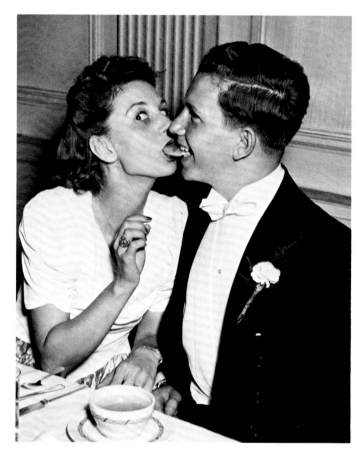

Samuel Cooper Studio
Brookline, MA
1940

Martin Schweig Studio
Early black-and-white wedding candid
St. Louis, MO
c. 1940

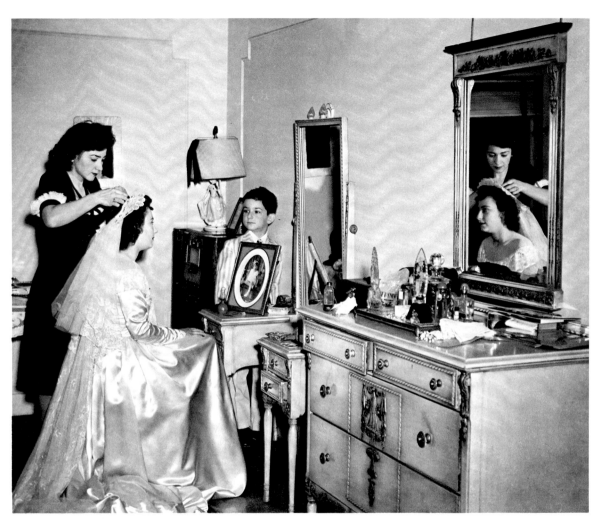

Samuel Cooper Studio
Brookline, MA
1940

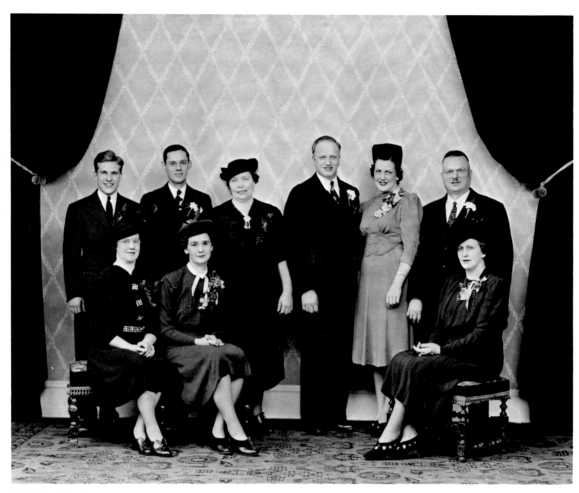

John Deusing Studio
West Allis, WI
1940

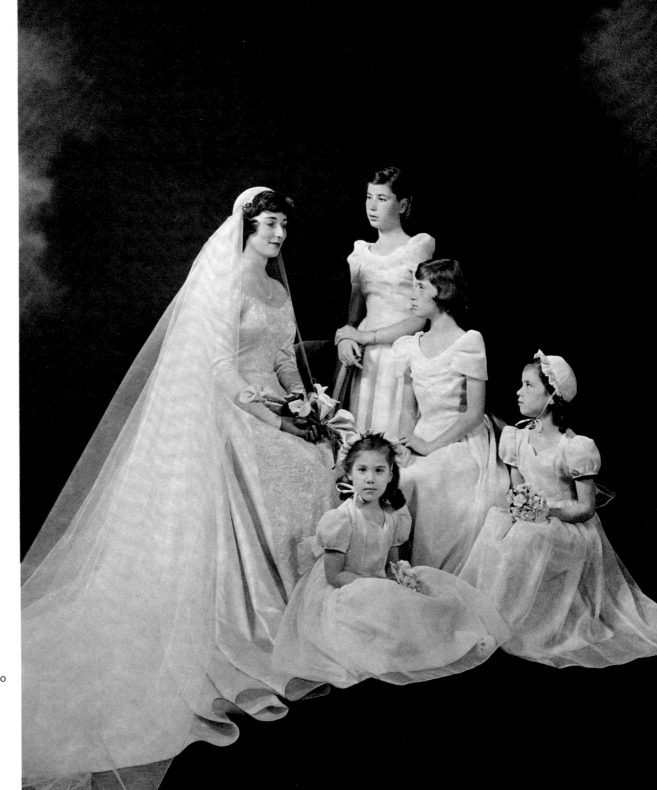

Bachrach Studio
East Coast
1943

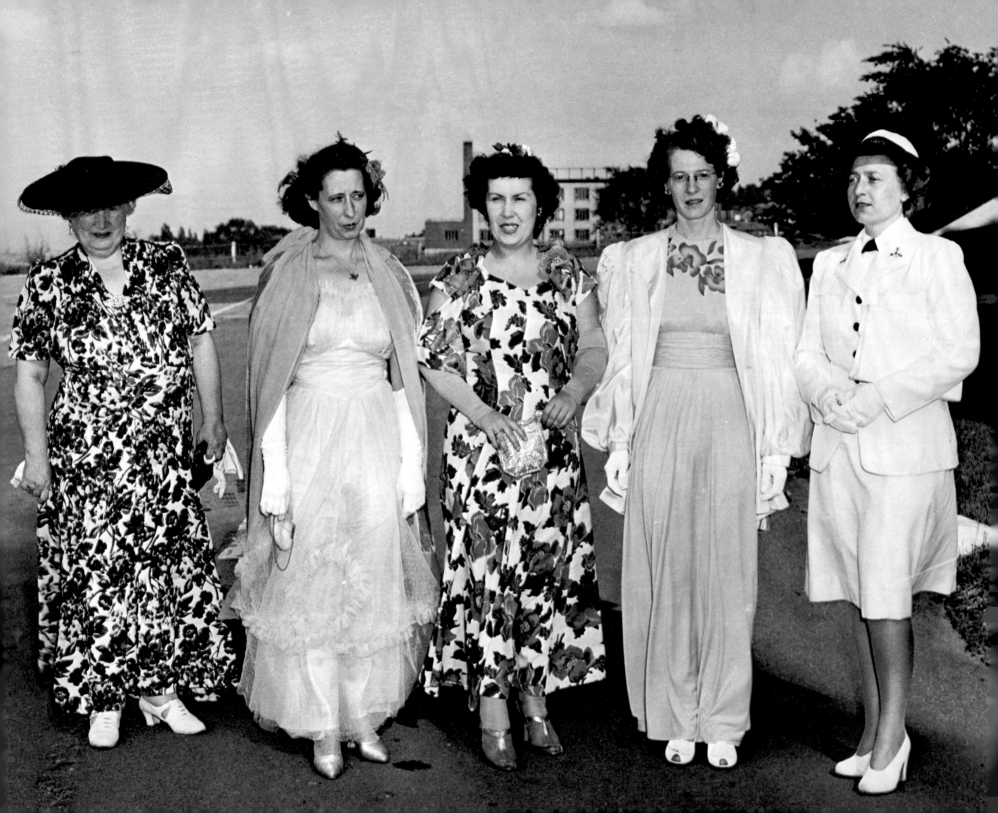

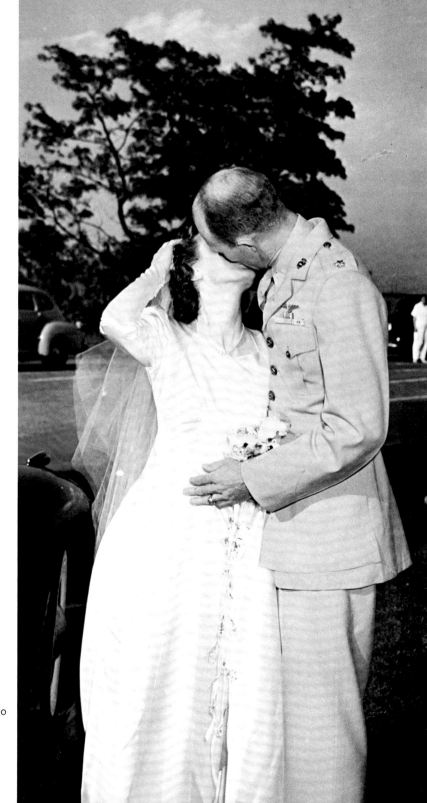

Samuel Cooper Studio
Brookline, MA
1944

Samuel Cooper Studio
Brookline, MA
1944

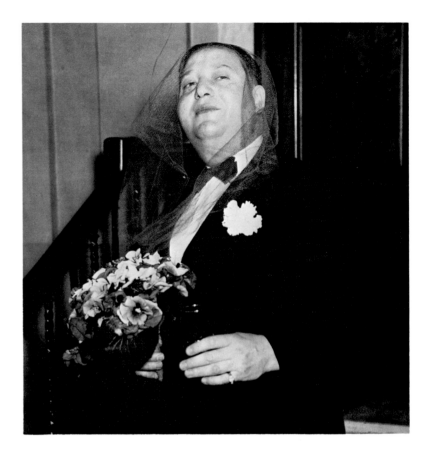

Samuel Cooper Studio
Brookline, MA
1944

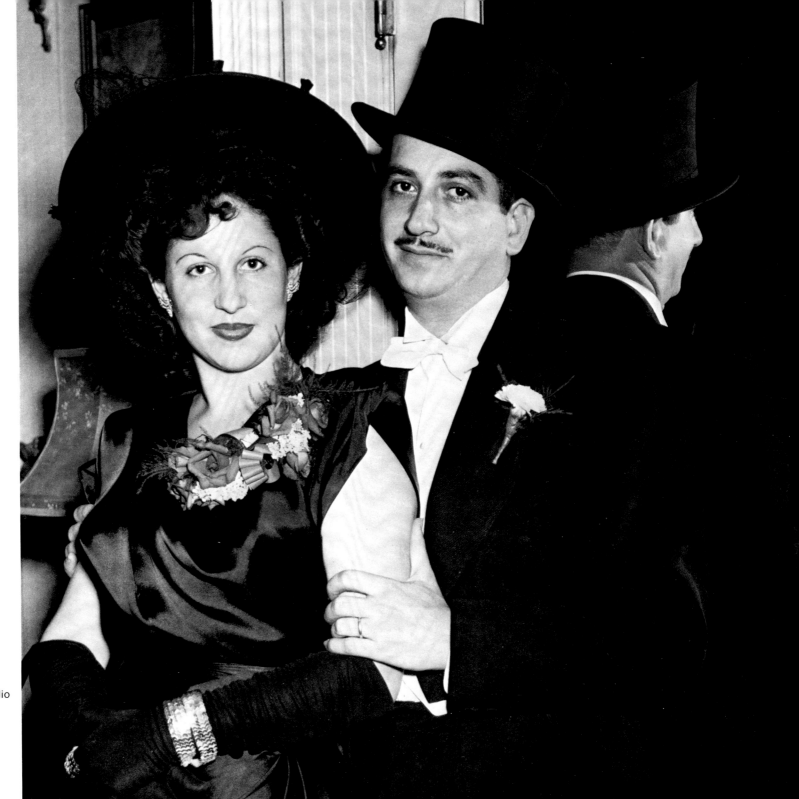

Samuel Cooper Studio
Brookline, MA
1944

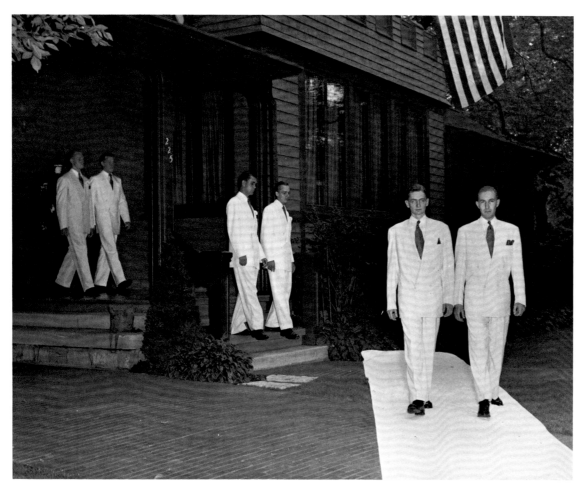

John Howell Studio
Winnetka, IL
1945

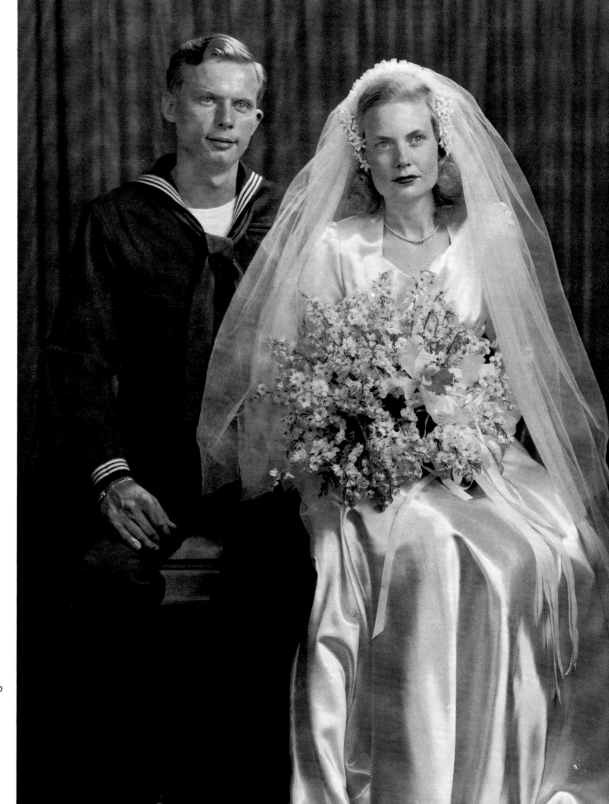

Martin Schweig Studio
St. Louis, MO
1945

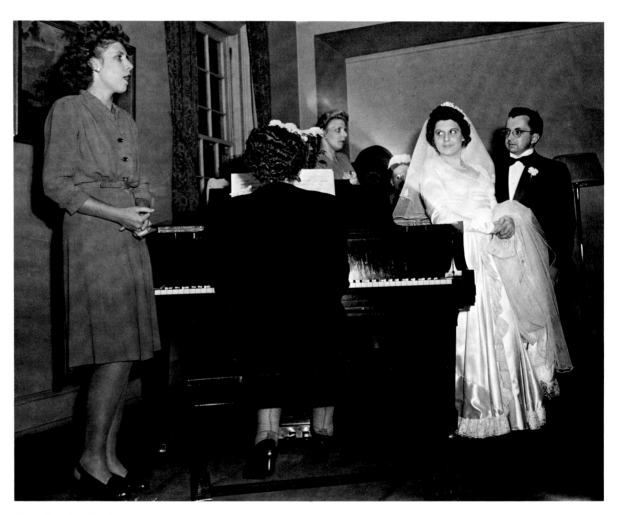

John Deusing Studio
West Allis, WI
1945

John Deusing Studio
West Allis, WI
1945

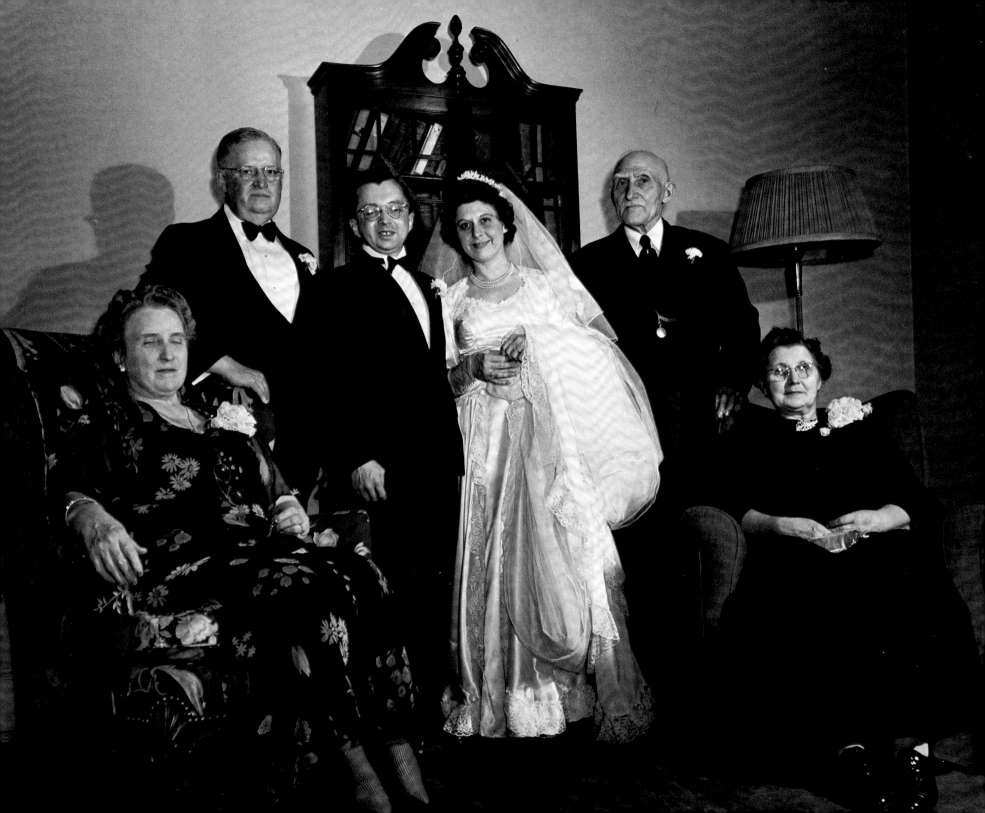

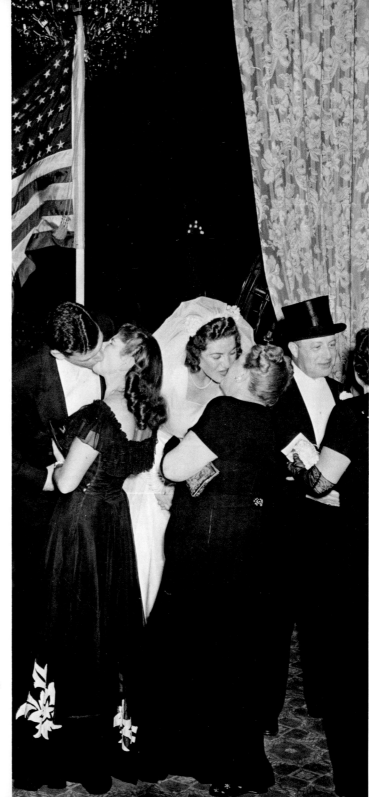

Samuel Cooper Studio
Brookline, MA
1946

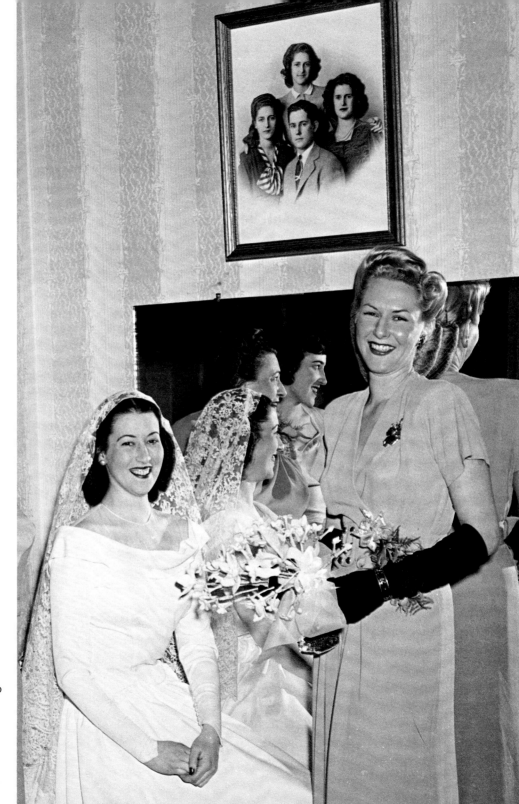

Samuel Cooper Studio
Brookline, MA
1946

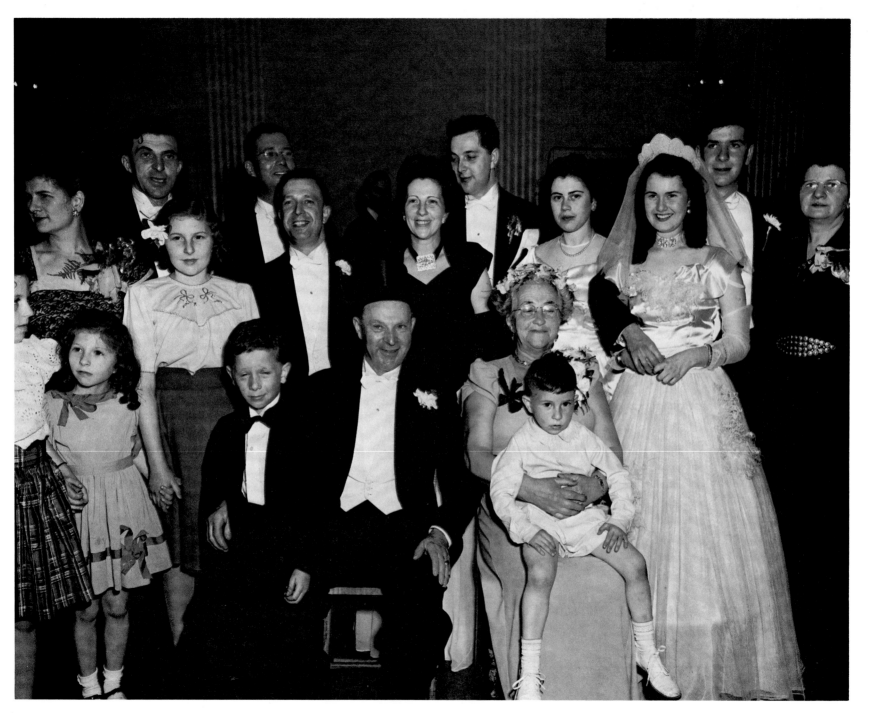

Samuel Cooper Studio
Brookline, MA
1946

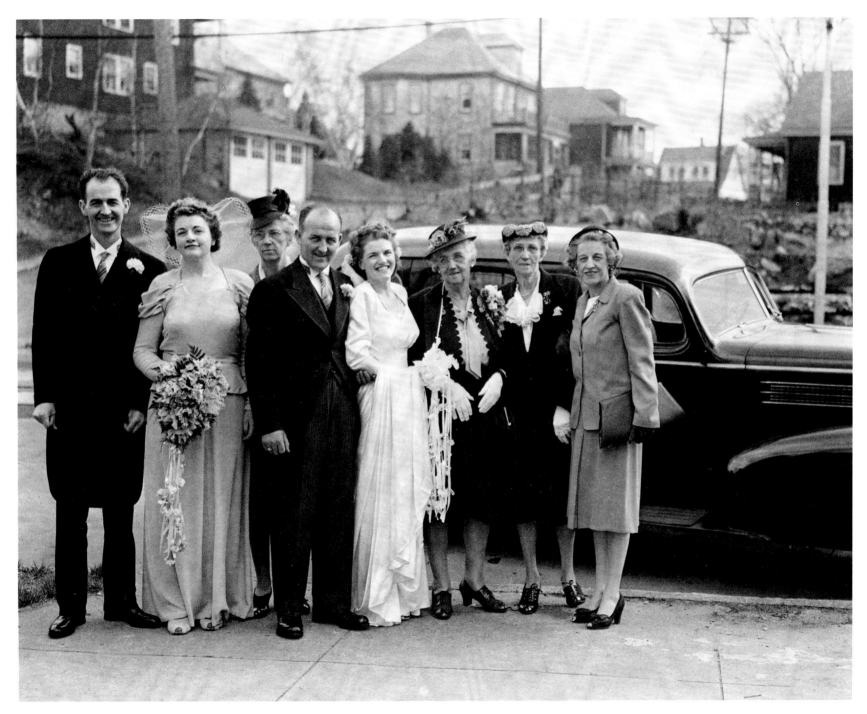

Samuel Cooper Studio
Brookline, MA
1946

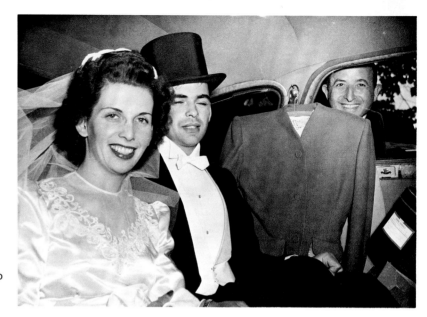

Samuel Cooper Studio
Brookline, MA
1946

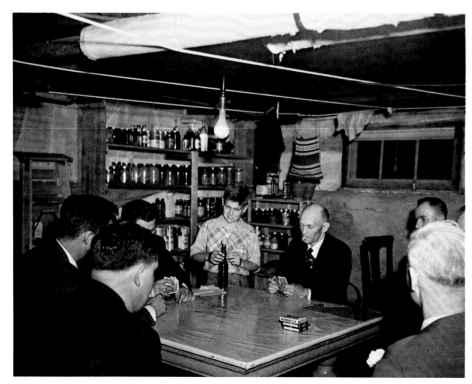

John Deusing Studio
West Allis, WI
1945

Samuel Cooper Studio
Brookline, MA
1946

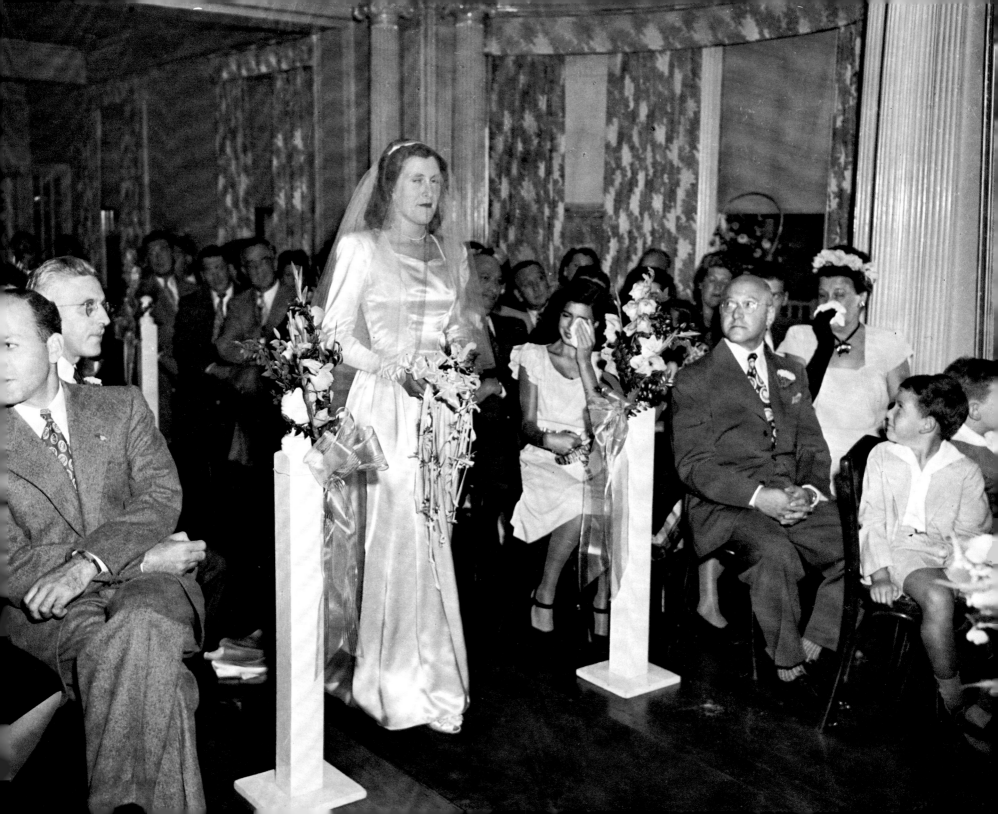

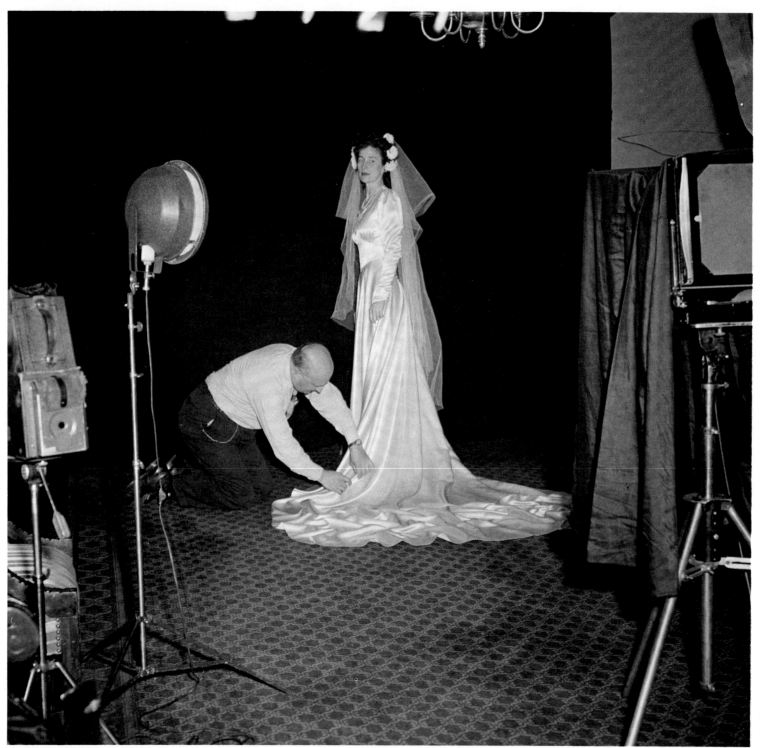

Samuel Cooper Studio
Brookline, MA
1946

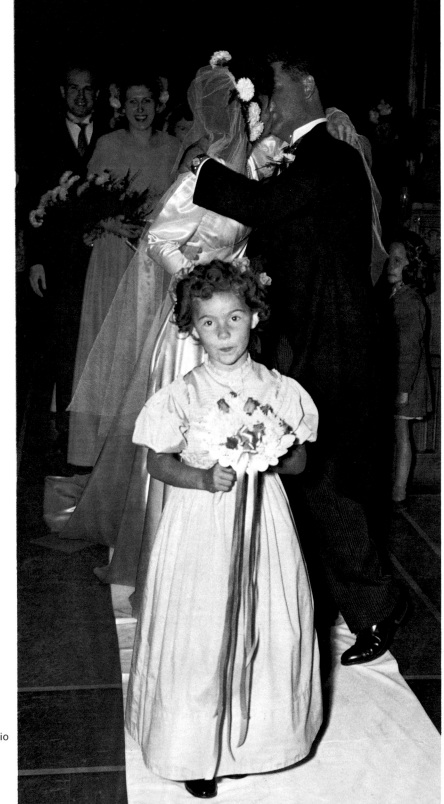

Samuel Cooper Studio
Brookline, MA
1946

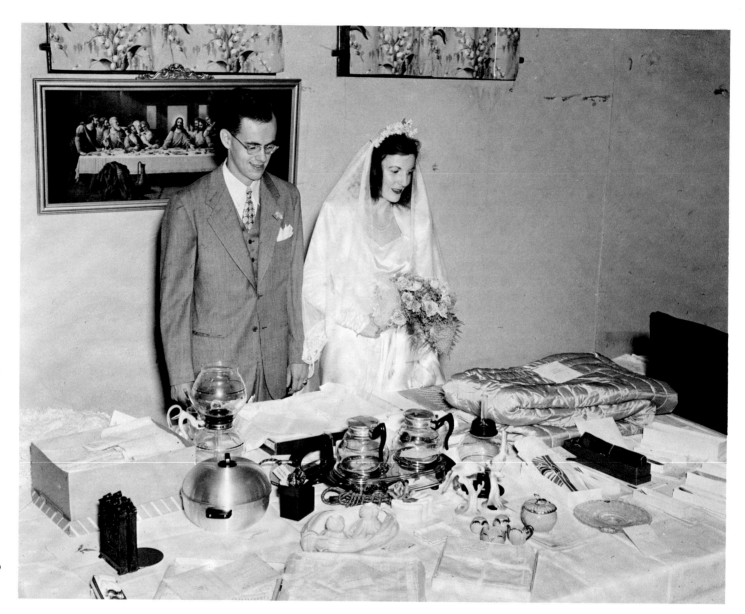

Orrion Barger Studio
Chamberlain, SD
1947

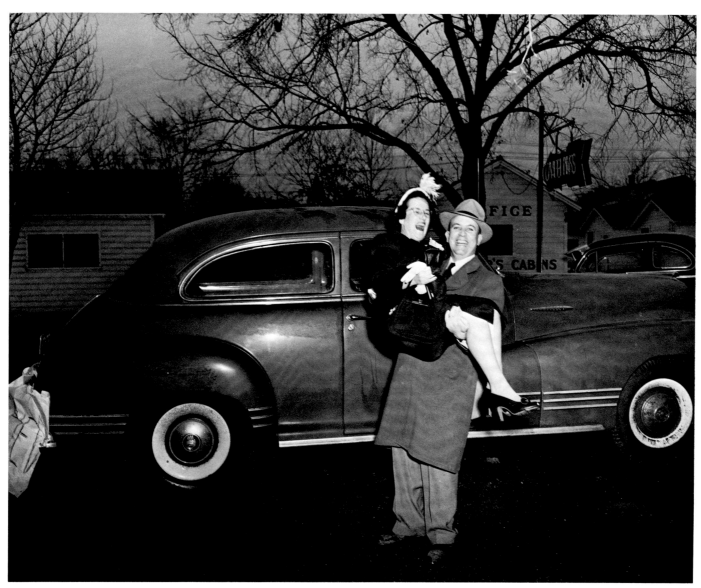

Orrion Barger Studio
Chamberlain, SD
1948

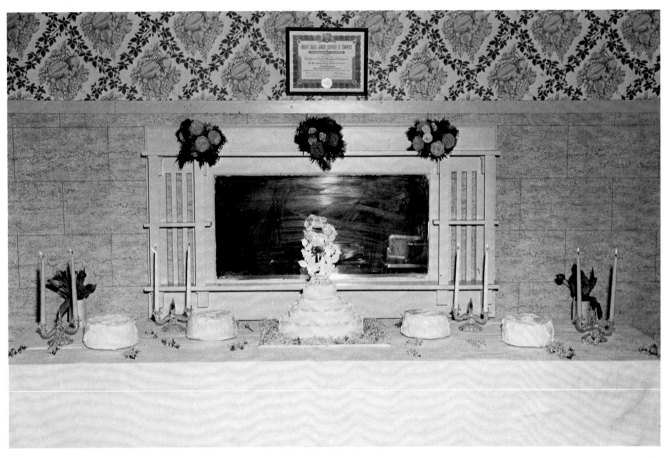

Orrion Barger Studio
Chamberlain, SD
1948

Orrion Barger Studio
Chamberlain, SD
1948

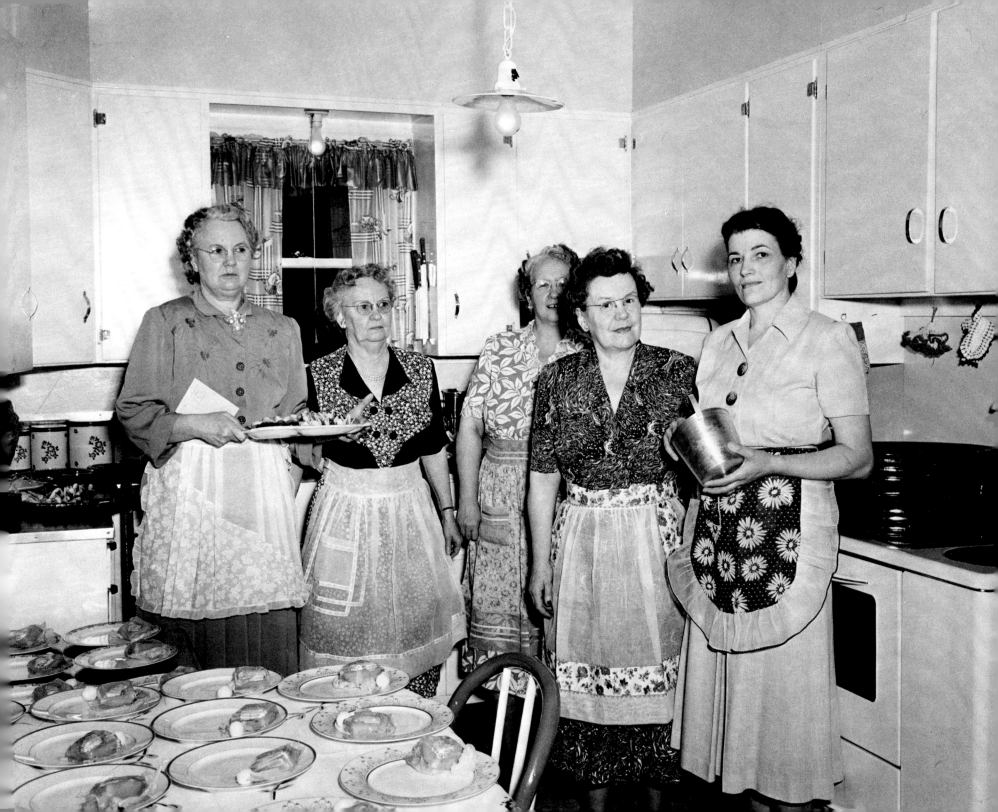

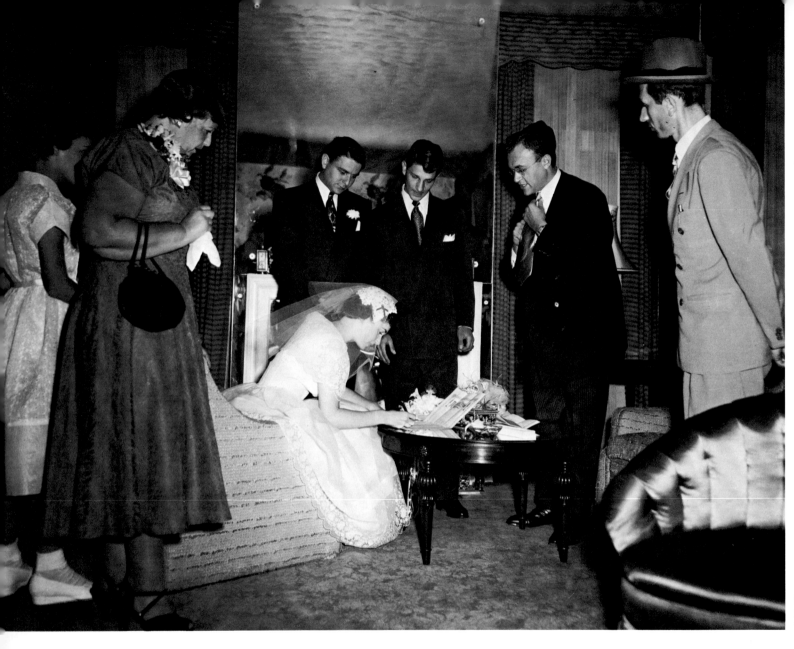

Samuel Cooper Studio
Brookline, MA
1950

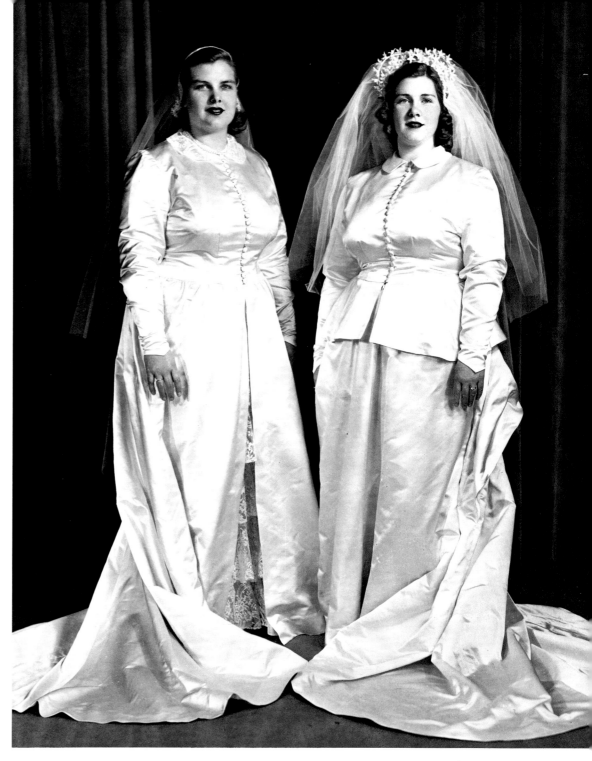

Martin Schweig Studio
St. Louis, MO
1949

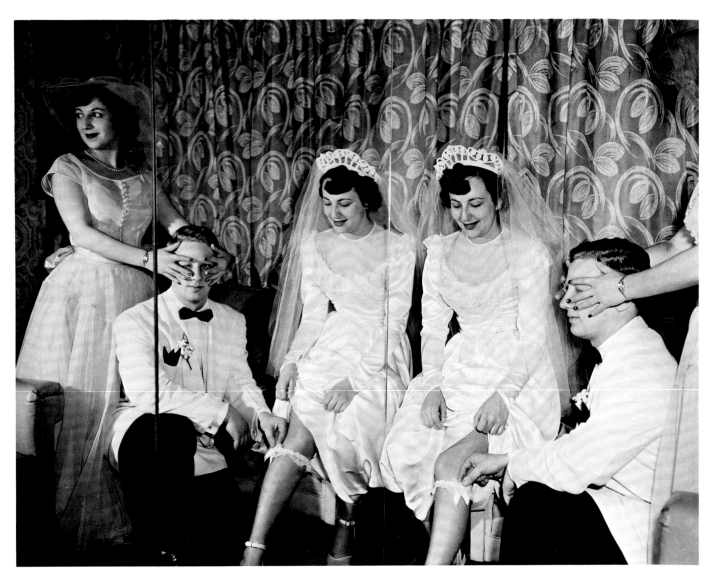

Samuel Cooper Studio
Brookline, MA
1950

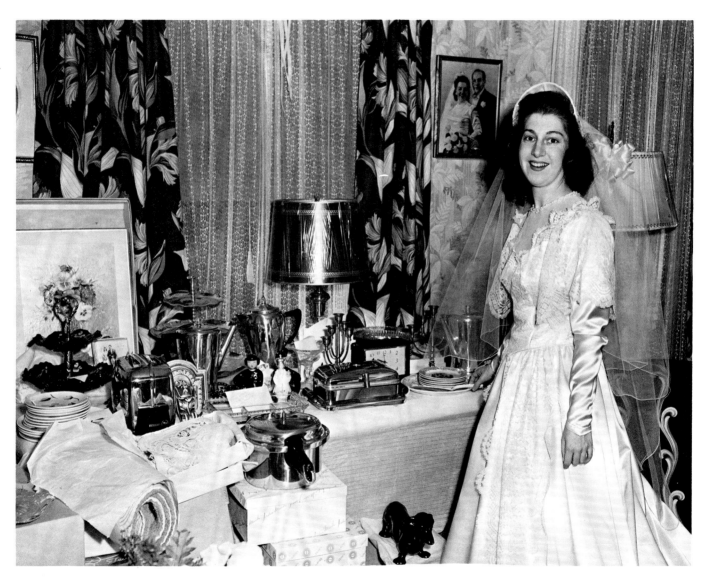

Samuel Cooper Studio
Brookline, MA
1950

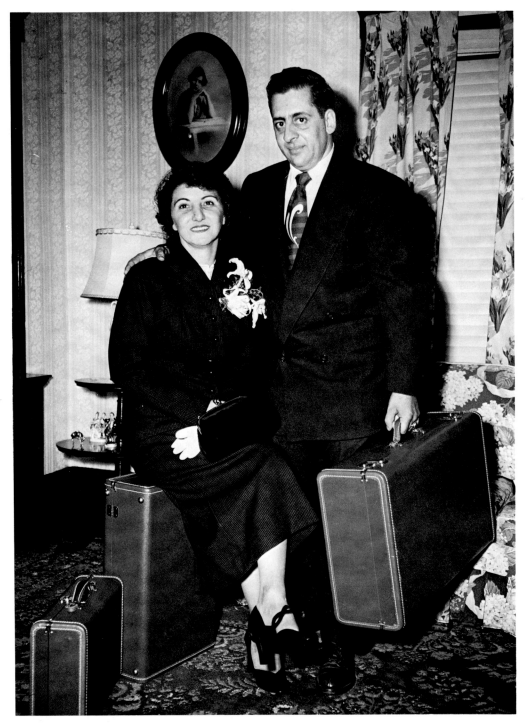

Samuel Cooper Studio
Brookline, MA
1950

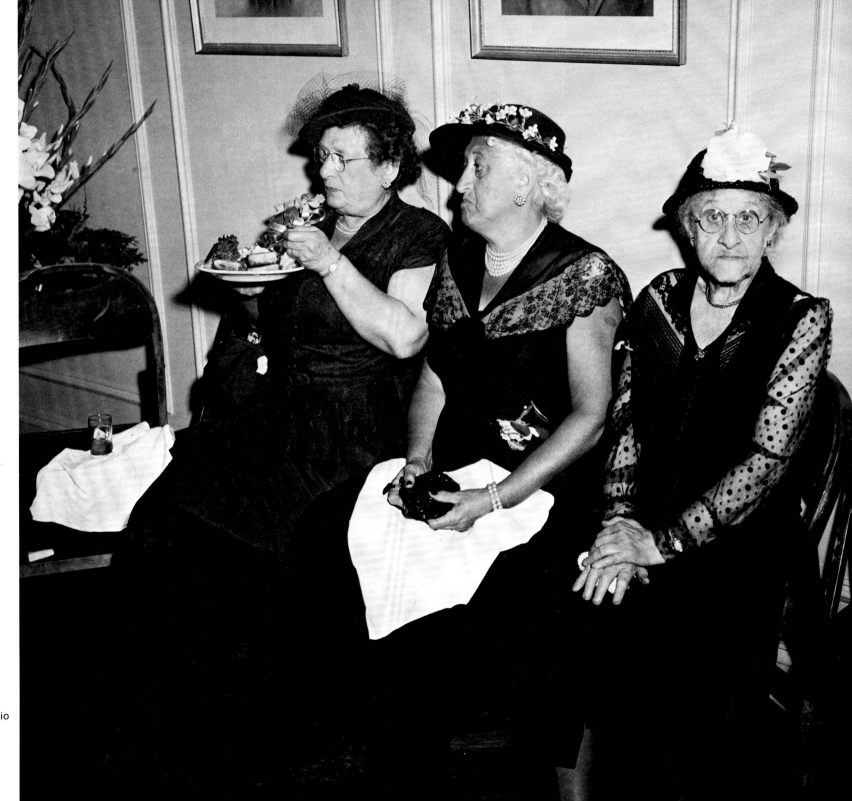

Samuel Cooper Studio
Brookline, MA
1950

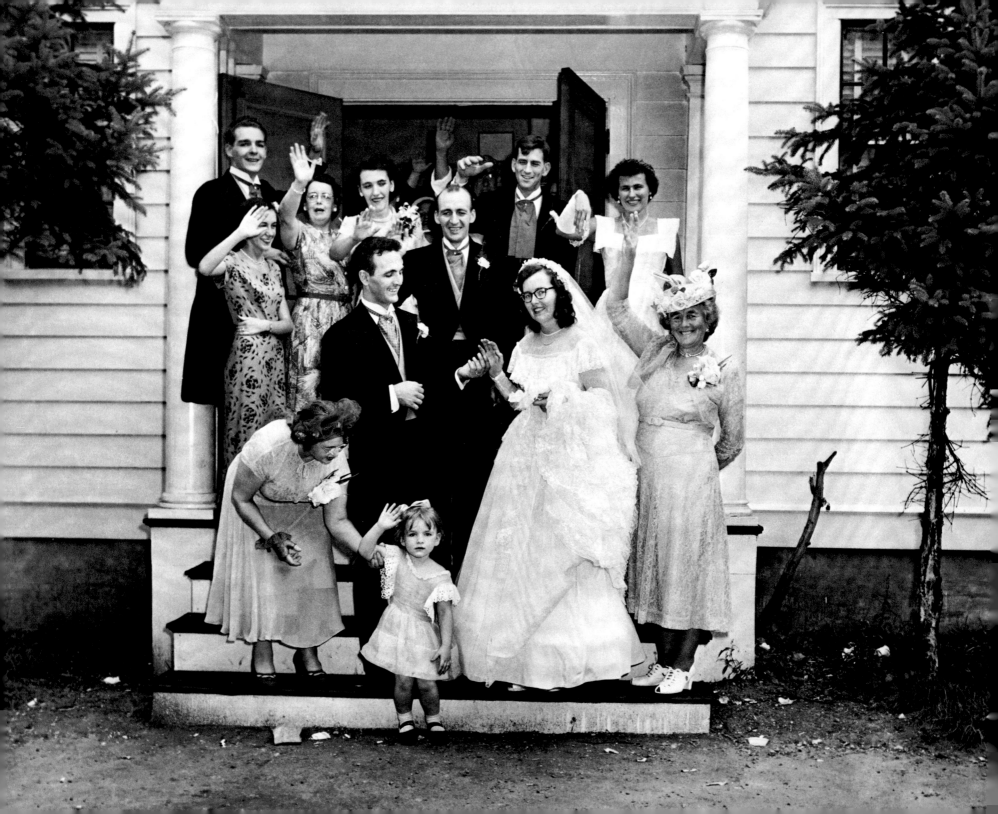

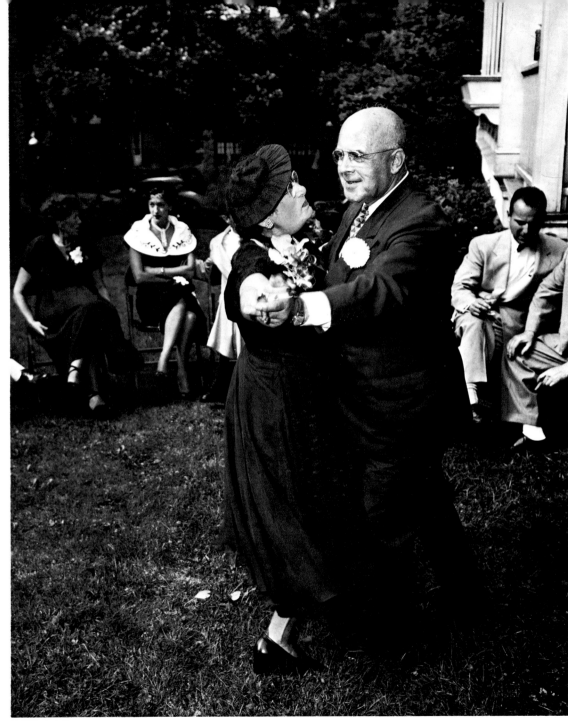

Samuel Cooper Studio
Brookline, MA
1950

Samuel Cooper Studio
Brookline, MA
1950

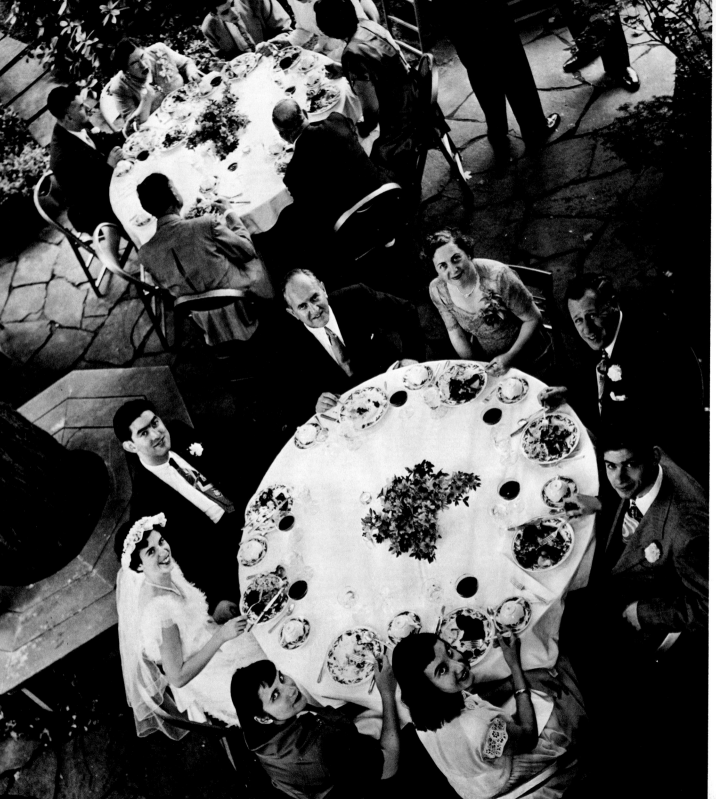

Samuel Cooper Studio
Brookline, MA
1950

Samuel Cooper Studio
Brookline, MA
1950

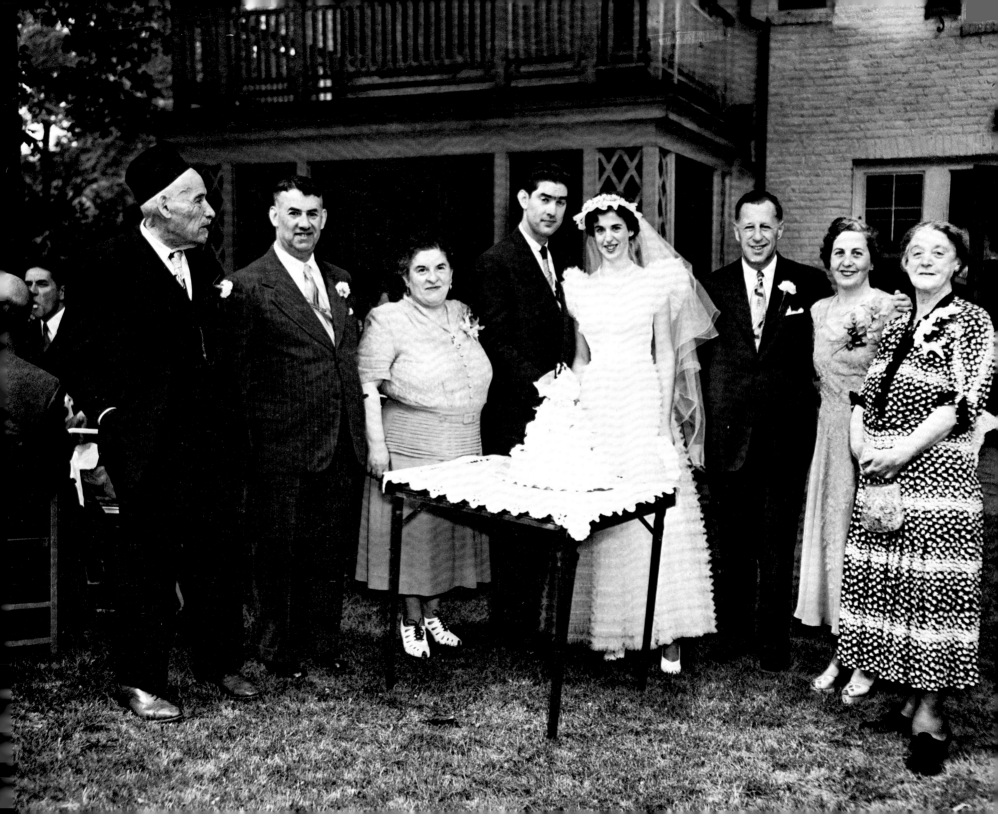

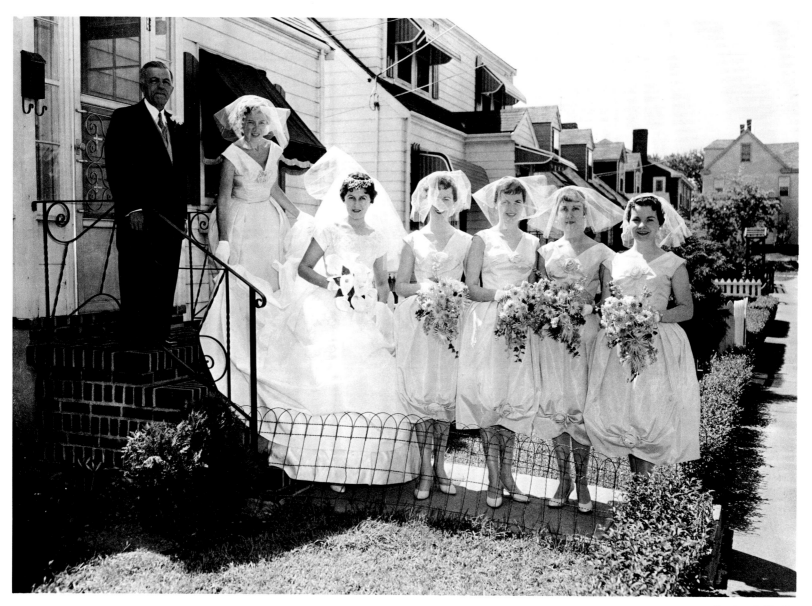

Bachrach Studio
East Coast
c. 1950s

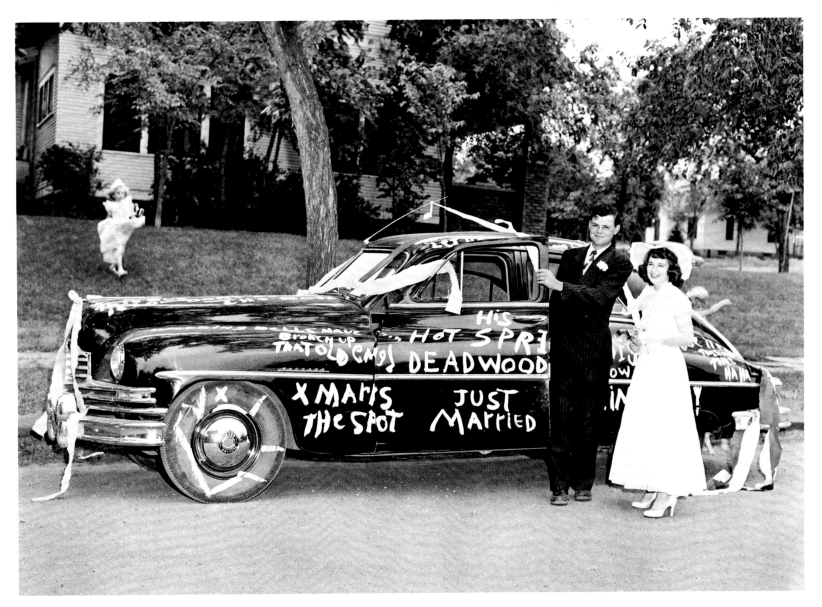

Orrion Barger Studio
Chamberlain, SD
1950

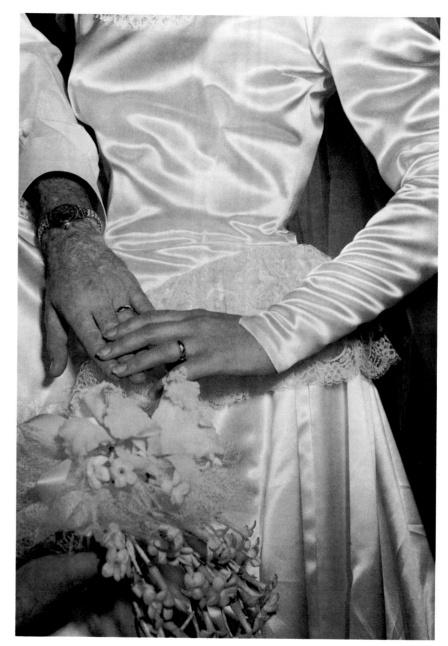

Samuel Cooper Studio
Brookline, MA
1950

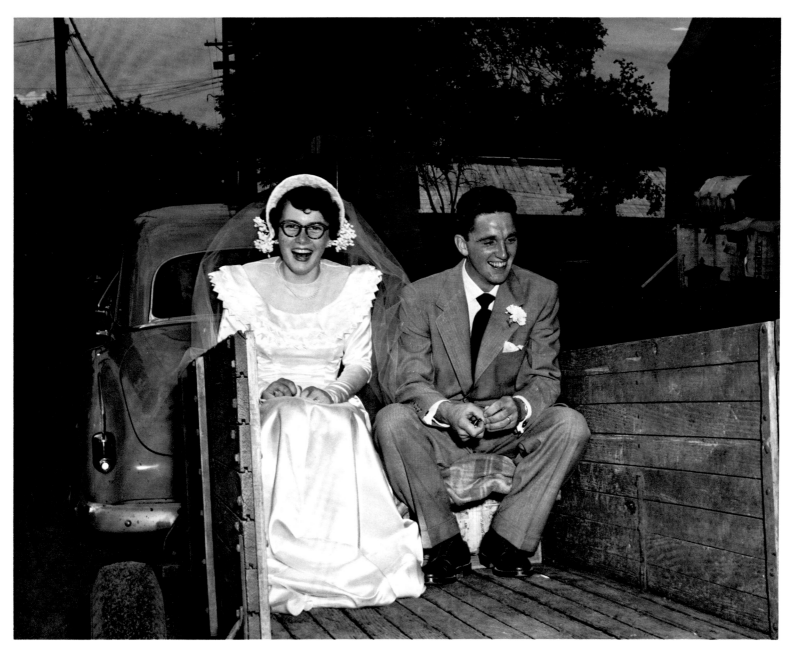

Orrion Barger Studio
Chamberlain, SD
1951

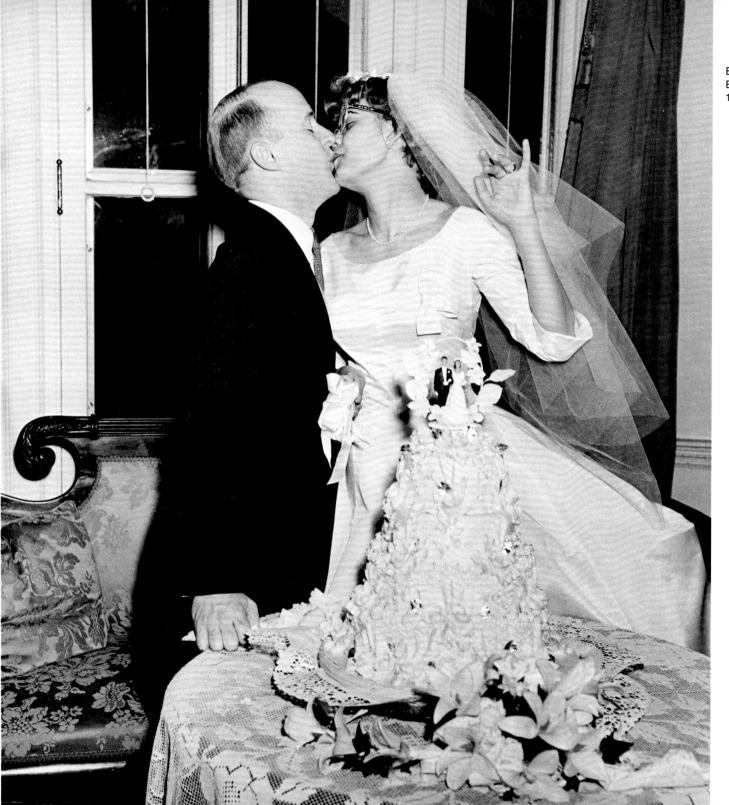

Bachrach Studio
East Coast
1954

Martin Schweig Studio
St. Louis, MO
1954

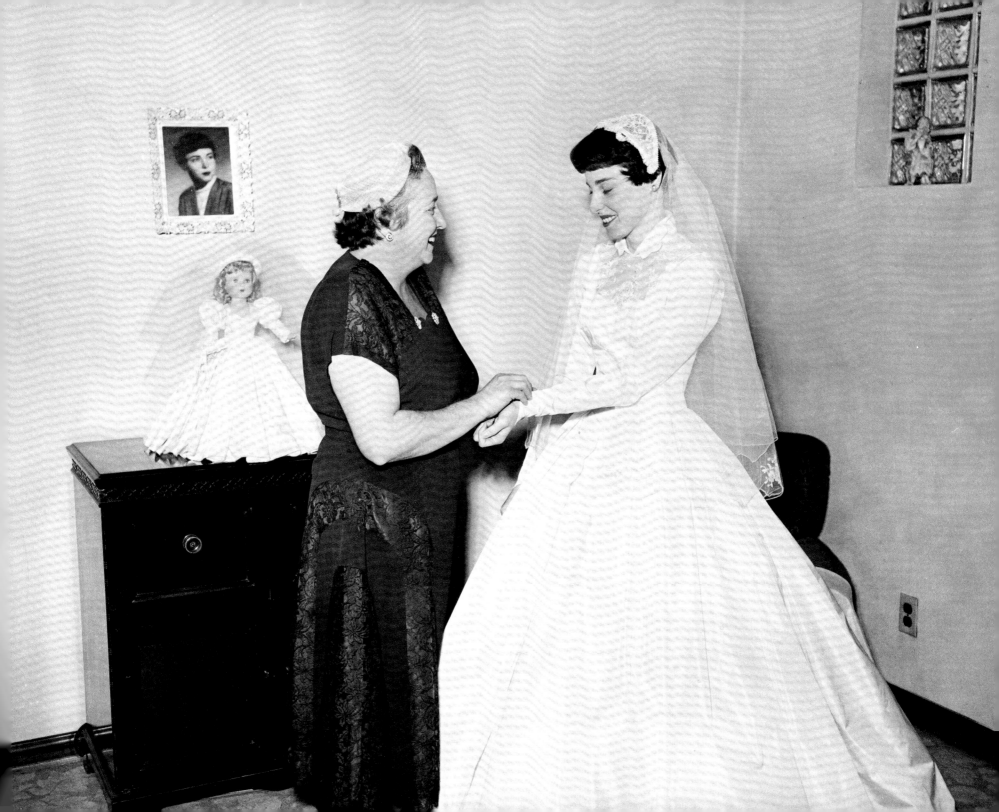

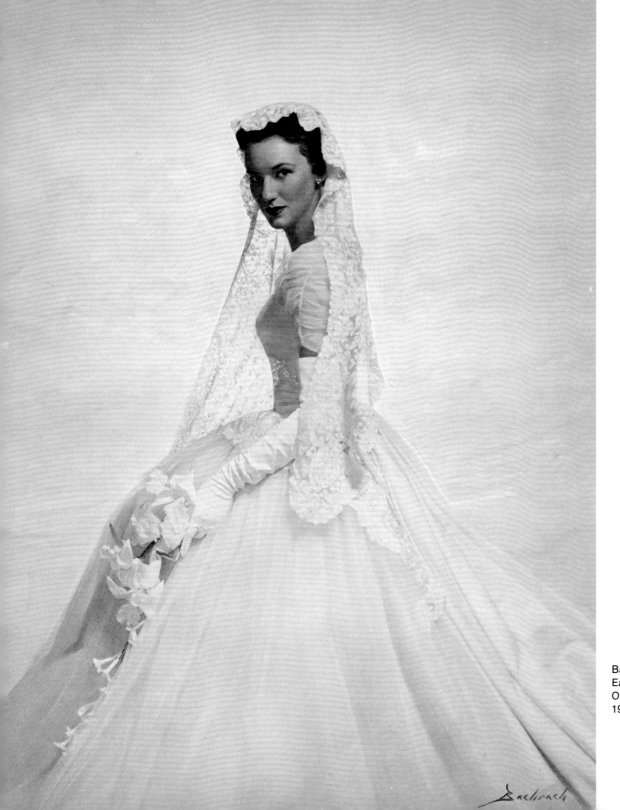

Bachrach Studio
East Coast
Oil-painted photograph
1955

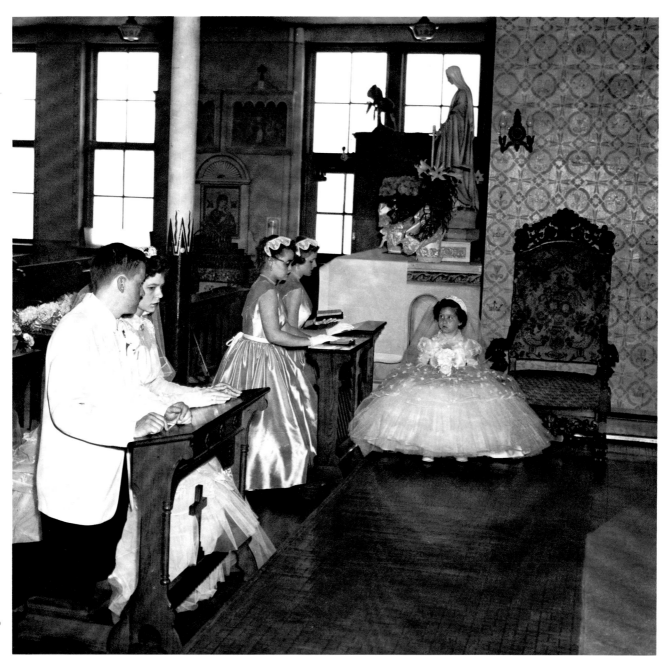

John Deusing Studio
West Allis, WI
1955

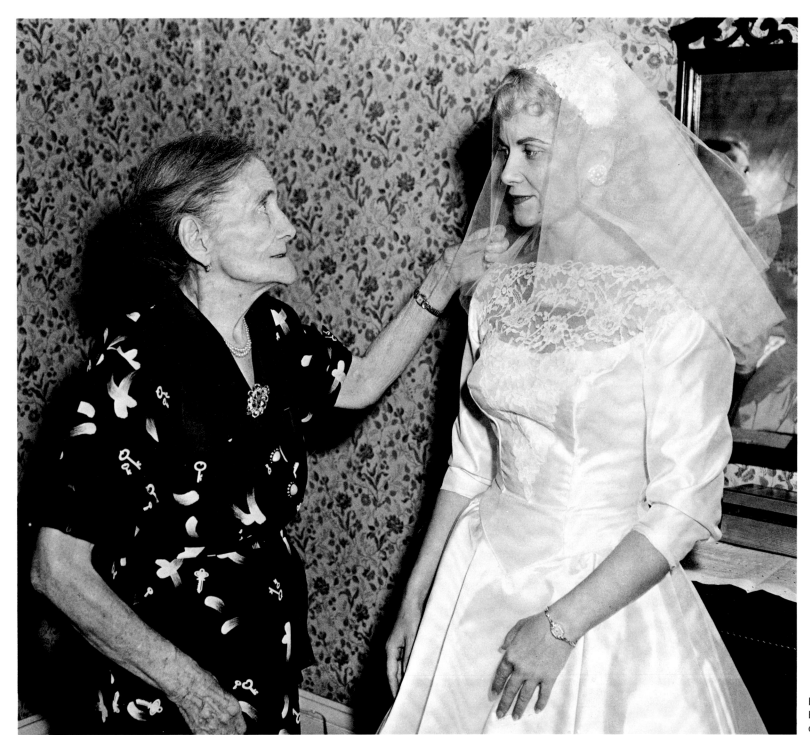

Bachrach Studio
East Coast
c. 1950s

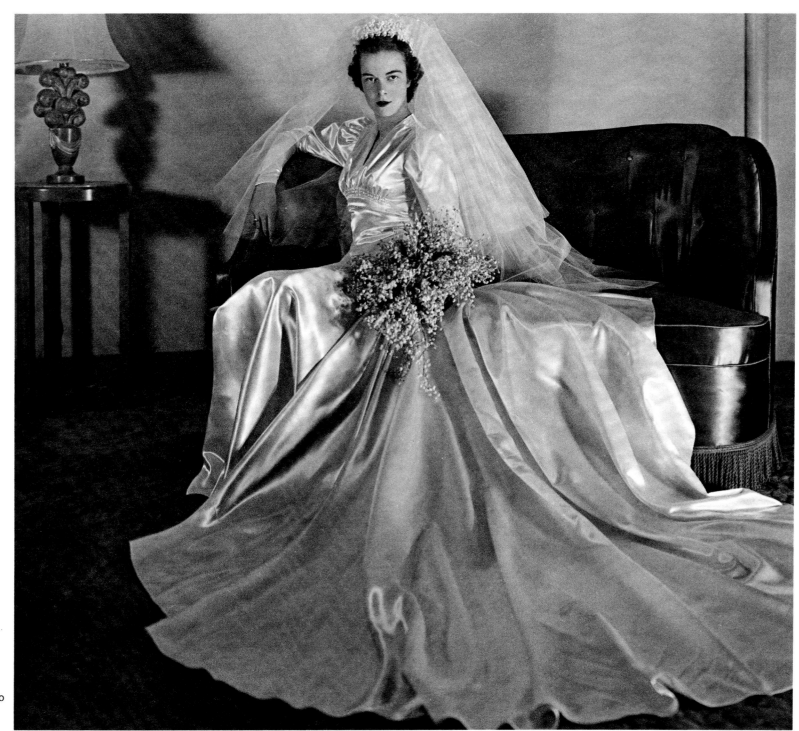

Martin Schweig Studio
St. Louis, MO
1955

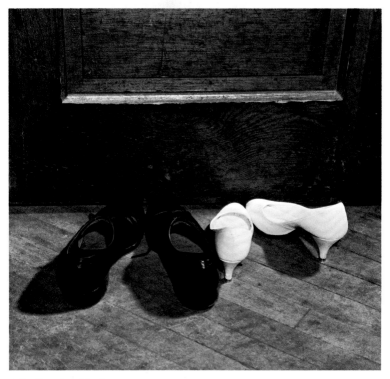

John Deusing Studio
West Allis, WI
1956

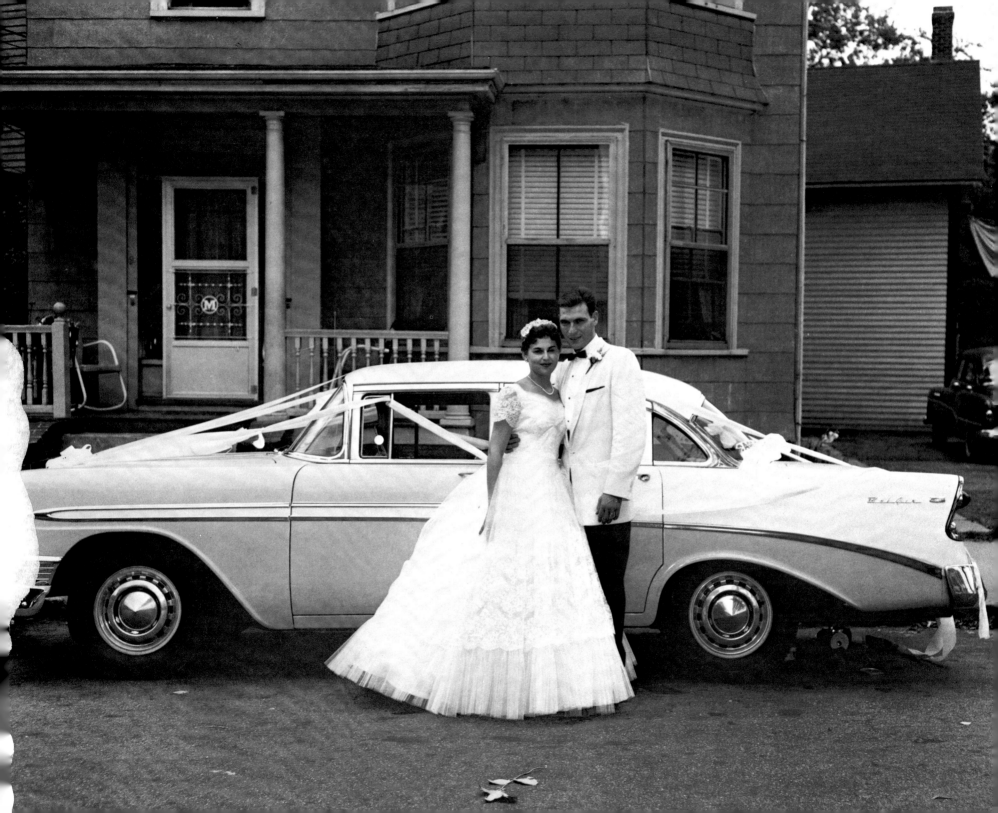

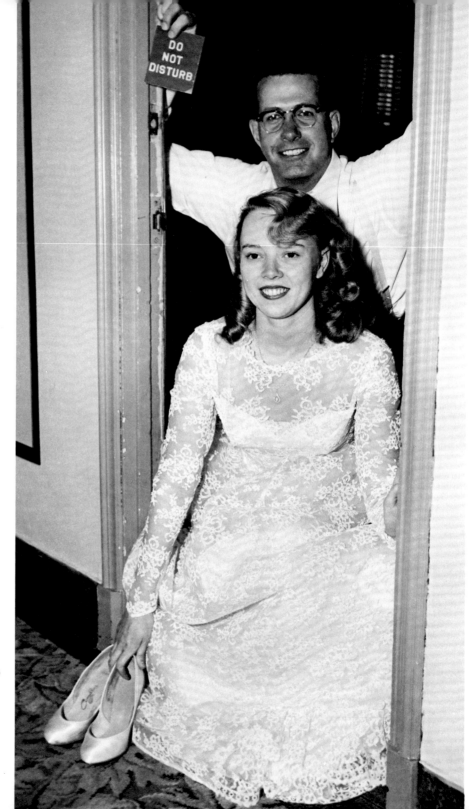

Samuel Cooper Studio
Brookline, MA
1956

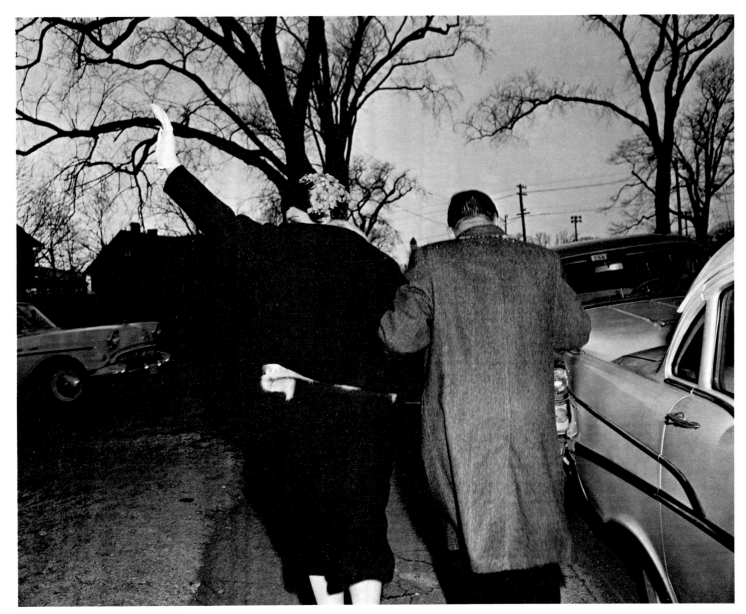

Bachrach Studio
East Coast
1958

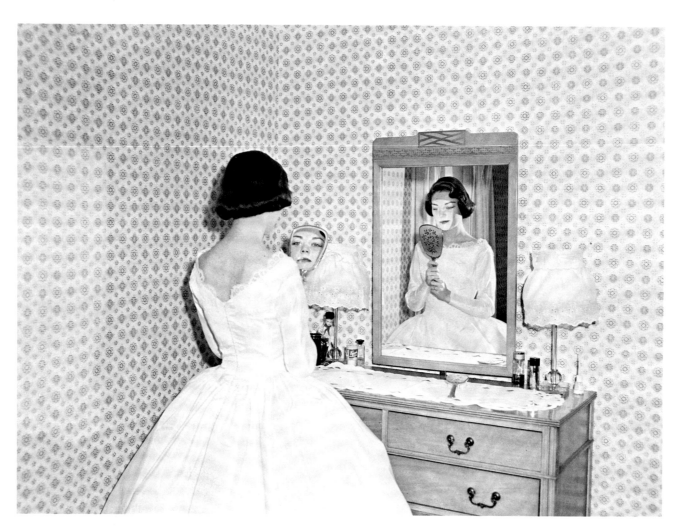

Bachrach Studio
East Coast
no date

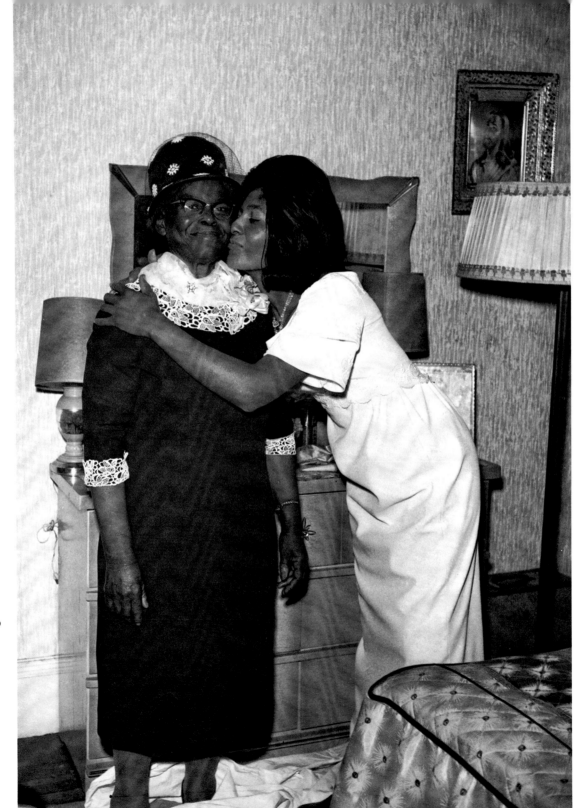

Clement McLarty Studio
Boston, MA
1963

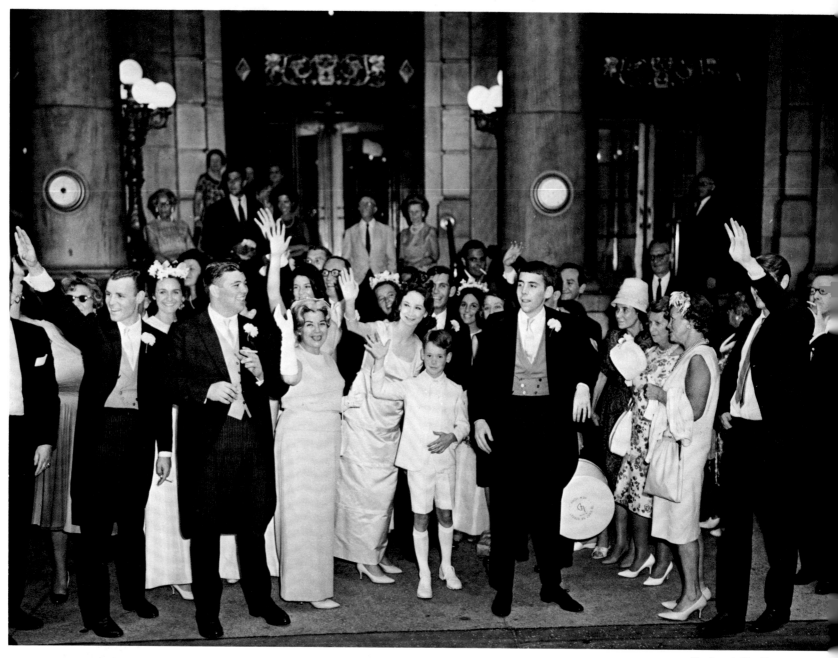

Bachrach Studio
East Coast
1950s

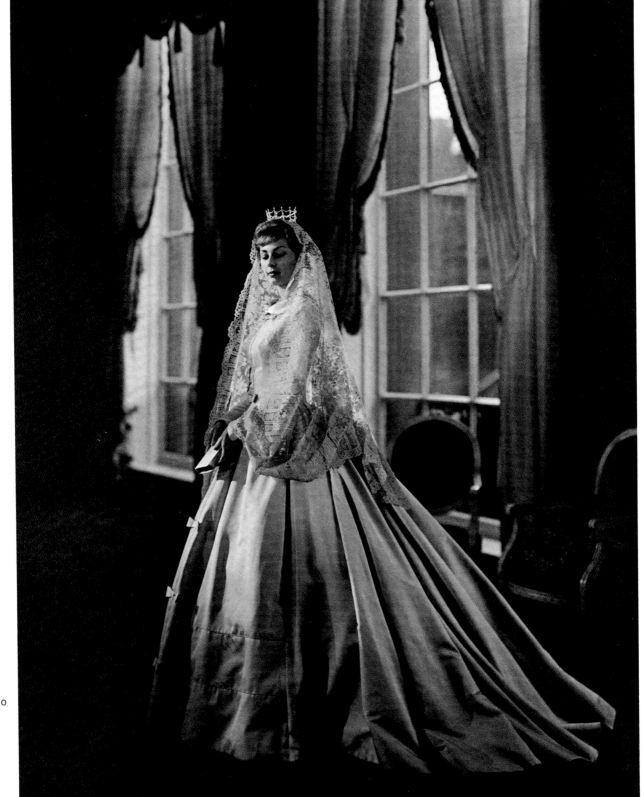

John Howell Studio
Winnetka, IL
1964

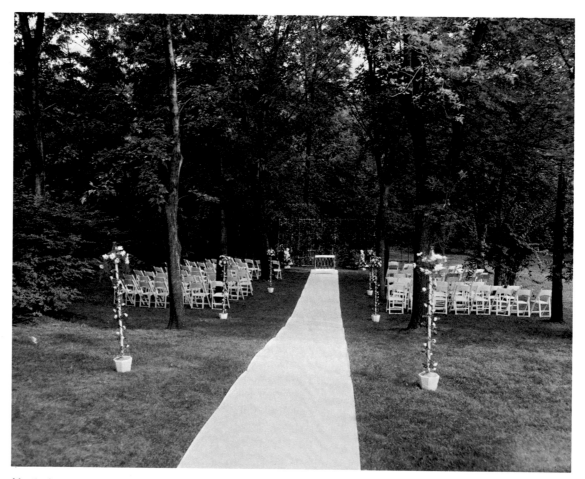

Martin Schweig Studio
St. Louis, MO
1960s

Martin Schweig Studio
St. Louis, MO
1960s

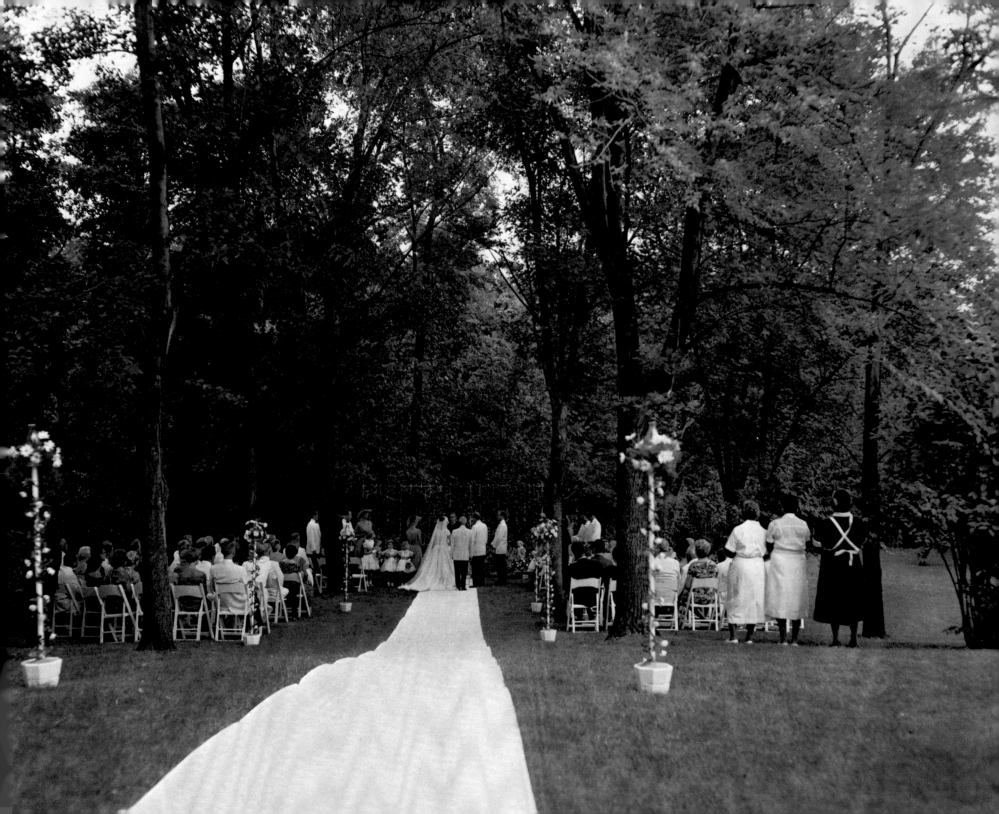

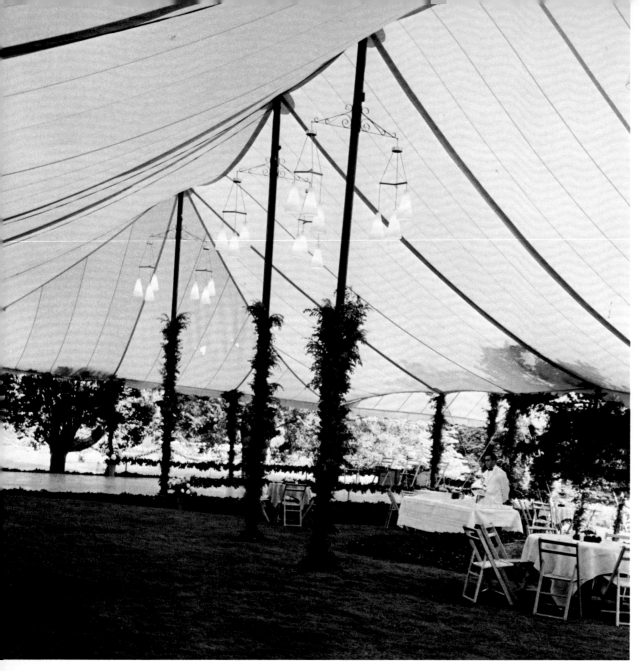

Bachrach Studio
East Coast
1964

Clement McLarty Studio
Boston, MA
1964

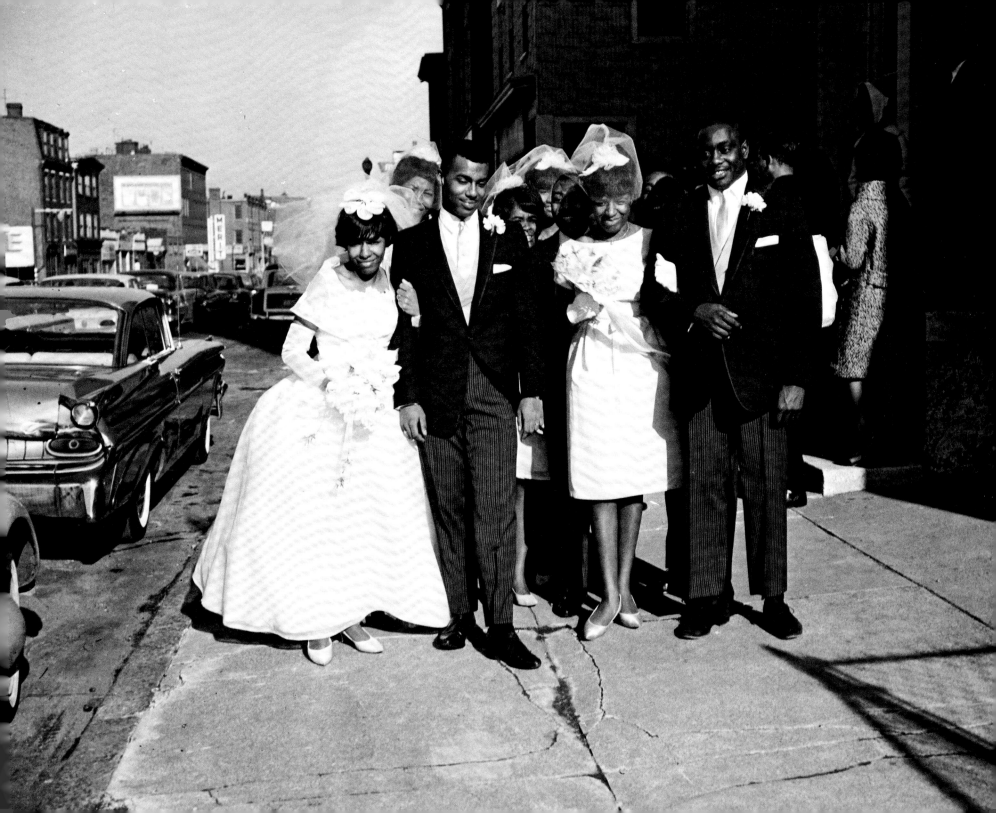

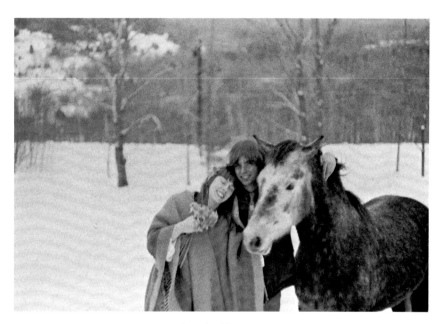

Color snapshot reproduced in black and white
c. late 1960s
Lent by Mary Beans

1965 to 1970

By 1965 almost all studios had changed from black-and-white photography to color photography for both formal portraits and for candids. This work is usually sent to outside labs for processing and printing. In a number of studios the new use of color film coincides with a decrease in originality and imagination in the candids. It is almost as if some photographers decided that color was enough, and that one could relax and take only the obvious shots. During this period many studios also substituted smaller negatives for both their portraits and their candids. The loss in quality is evident.

The craft of coloring black-and-white portraits is also disappearing, although a number of art photographers are learning the skill now that it has been abandoned by the studio photographer.

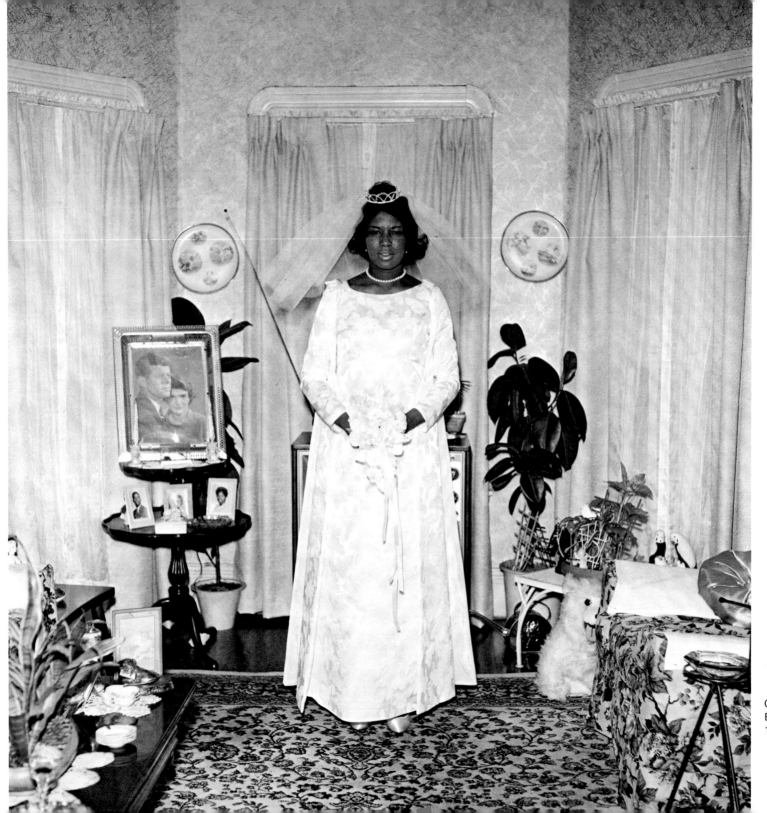

Clement McLarty Studio
Boston, MA
1965

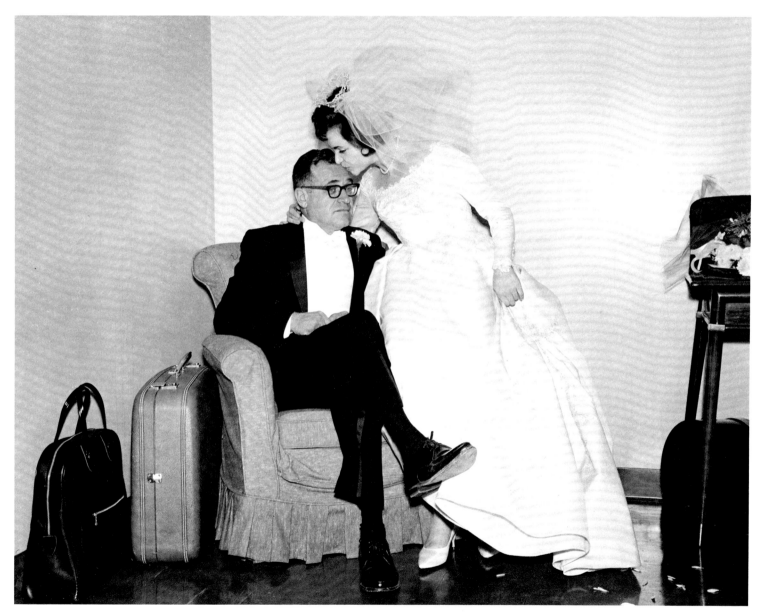

Samuel Cooper Studio
Brookline, MA
1965

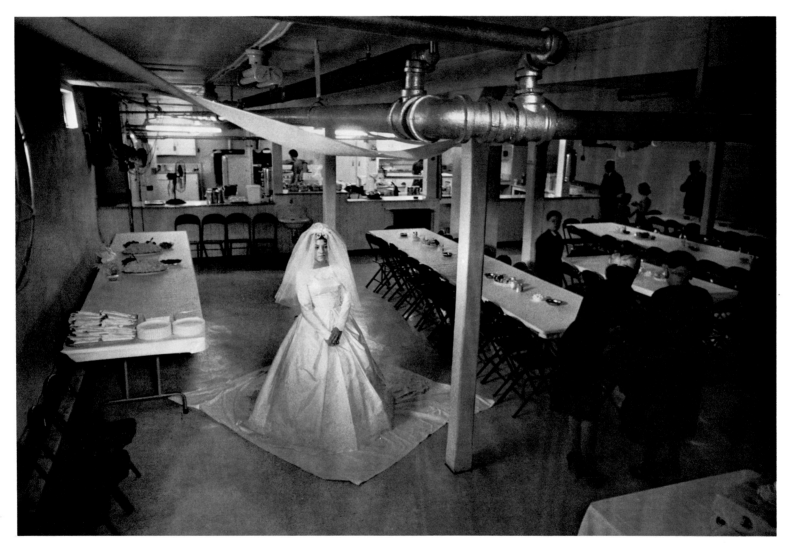

Charles Harbutt
1965
Lent by Magnum Photos Inc.

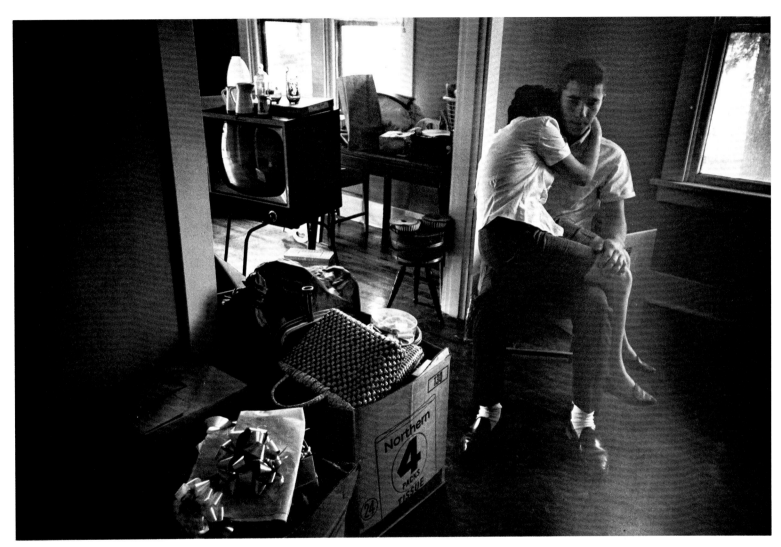

Charles Harbutt
1965
Lent by Magnum Photos Inc.

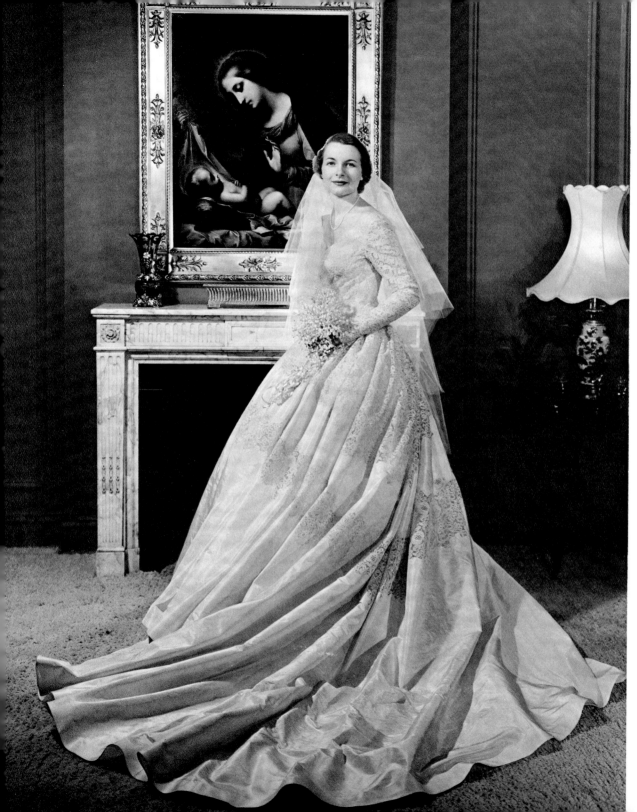

John Howell Studio
Winnetka, IL
1965

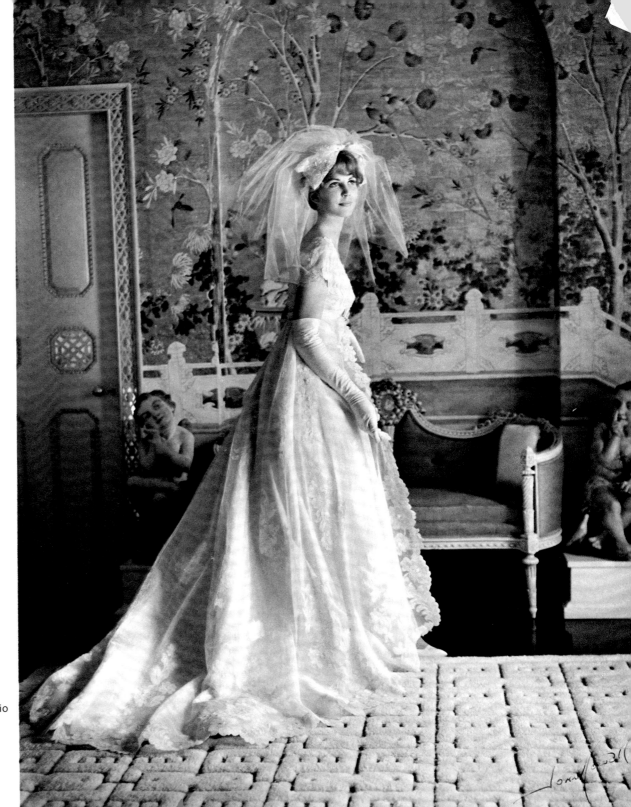

John Howell Studio
Winnetka, IL
1965

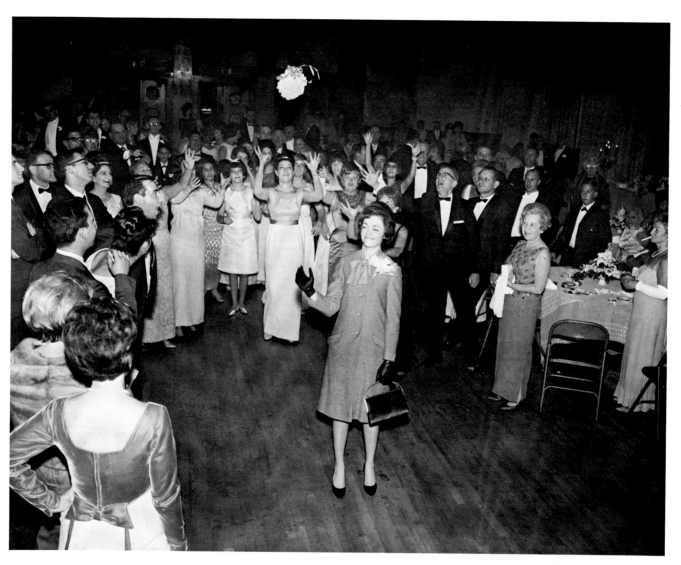

Samuel Cooper Studio
Brookline, MA
1965

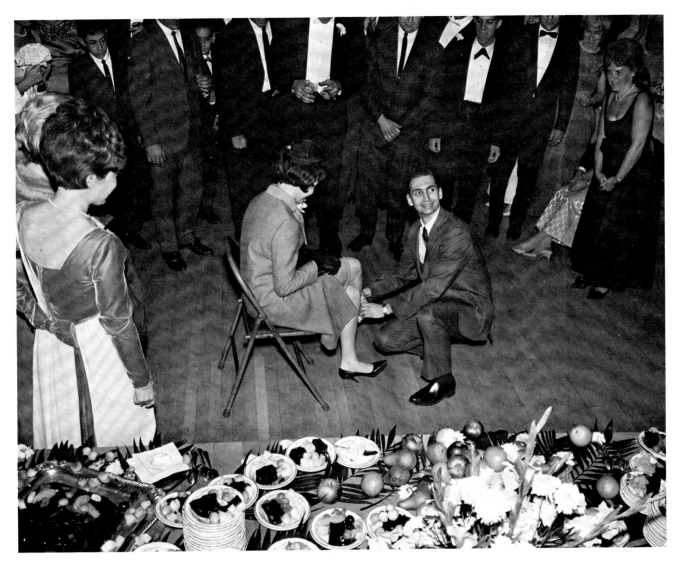

Samuel Cooper Studio
Brookline, MA
1965

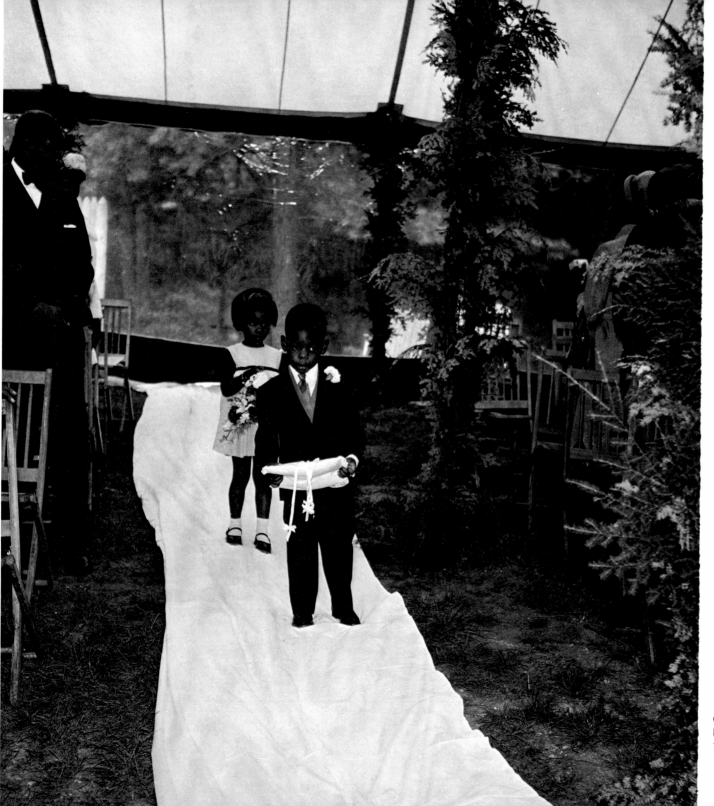

Clement McLarty Studio
Boston, MA
1965

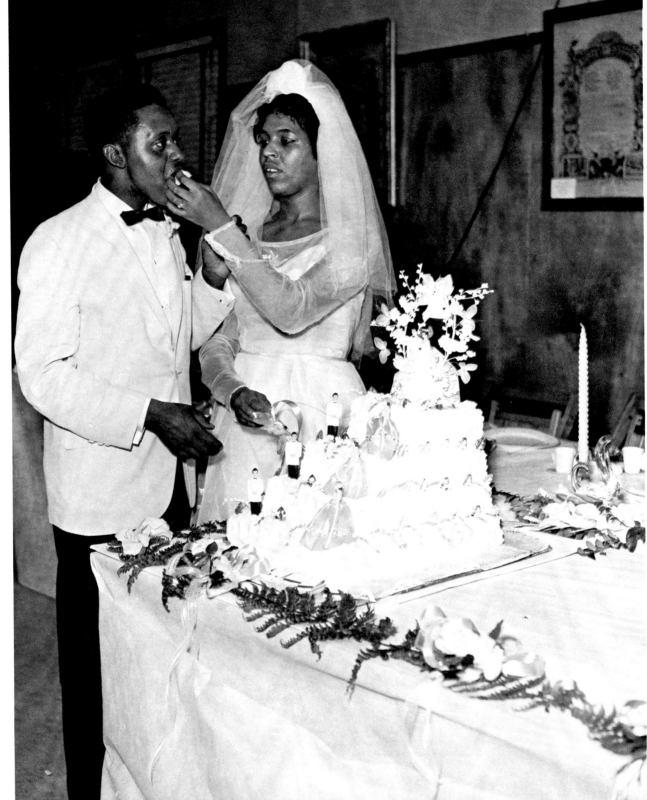

Clement McLarty Studio
Boston, MA
1965

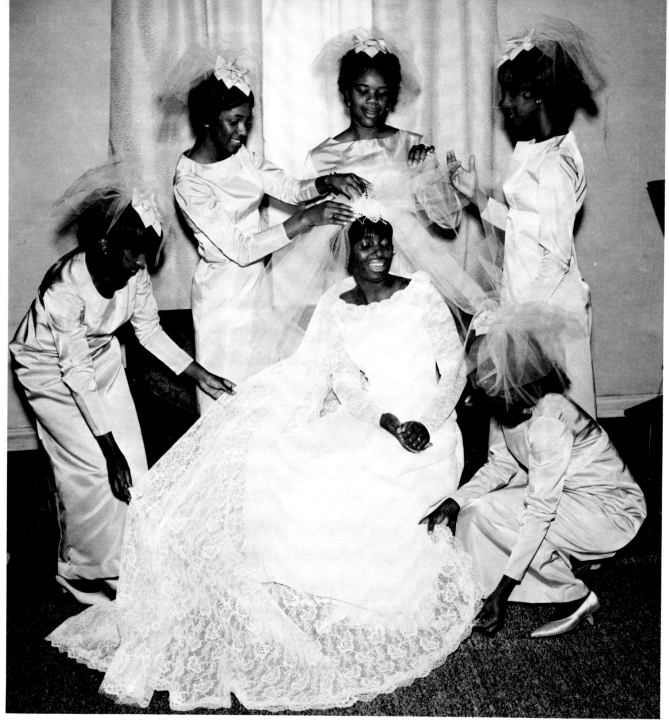

Clement McLarty Studio
Boston, MA
1966

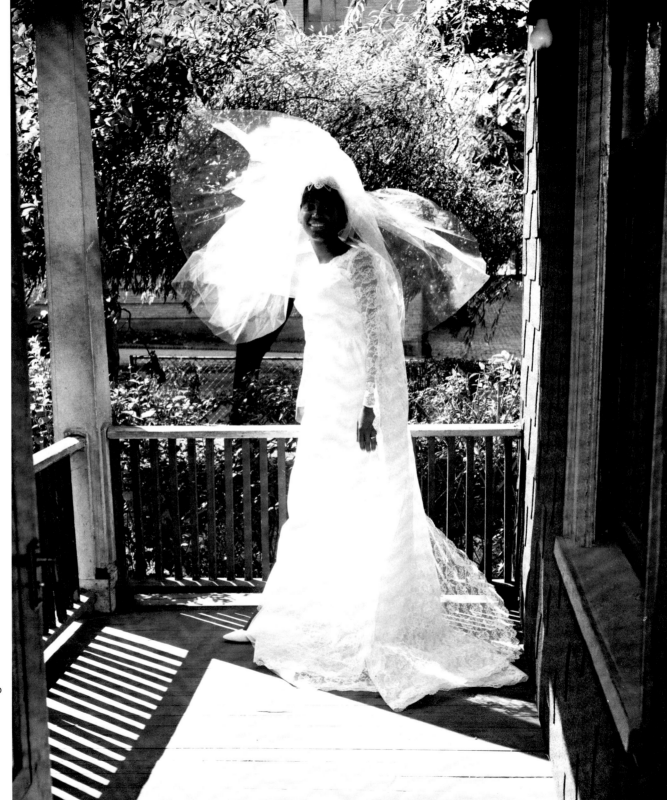

Clement McLarty Studio
Boston, MA
1966

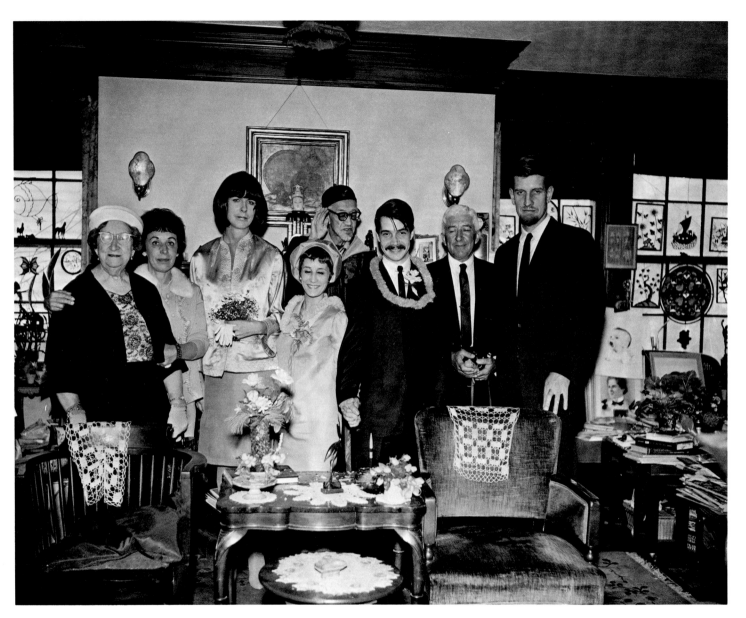

Clement McLarty Studio
Boston, MA
c. 1969

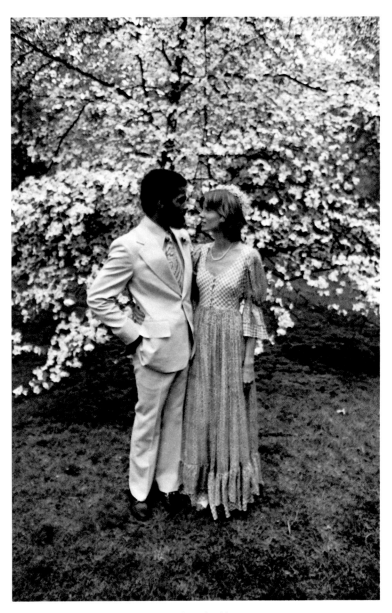

Color snapshot reproduced in black and white
c. late 1960s
Lent by Hope Norwood

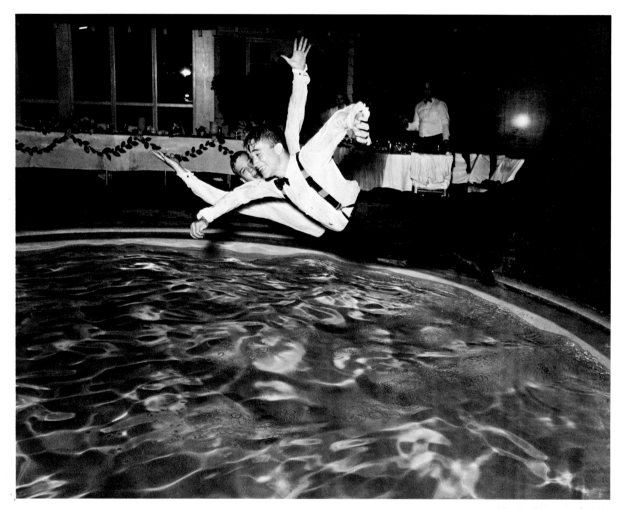

Martin Schweig Studio
St. Louis, MO
c. 1960s

Bachrach Studio
East Coast
c. 1960s

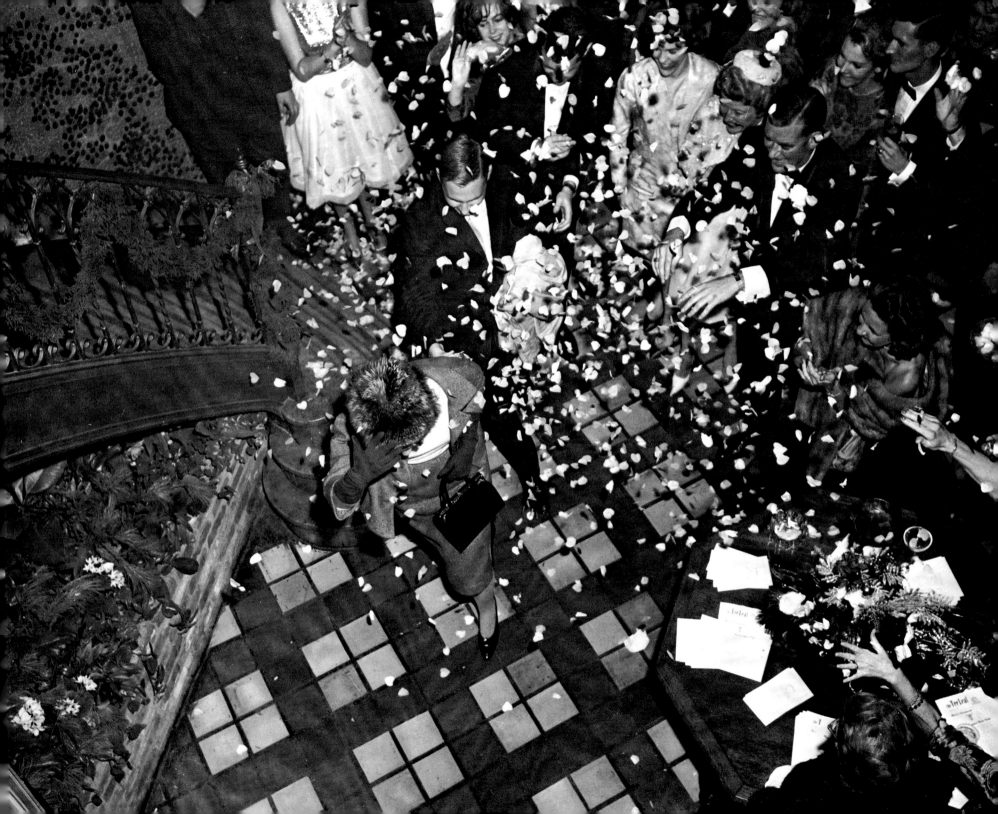

1970 to 1979

During the 1970s many studios included set-up color candids in the wedding package of pictures. These pictures are the product of the photographer's imagination. There are Casuals (posed candids), Mistys (soft focus with trick photography—for example, gadgets that turn candle flames into hearts) and Fantasies (double exposures which put the wedding couple inside a wine glass or inside one another's head). The addition of these complex prints represents an attempt to give the customer a product beyond the talents of the amateur photographer.

The days of the great studio photographers are slowly coming to an end in the United States just as they have in Europe. Competition from talented amateurs, the availability of very cheap department store portraits, the high cost of hiring a talented craftsman for a day to photograph a wedding, and the fragile position of the institution of marriage have all contributed to a decrease in the demand for fine studio work. Business demand for portraiture of executives has helped slow the closing of studios. But the prolific age of wedding photography which started in 1940, a period of carefully taken fine portraits and candids which were developed and printed with technical perfection in the studio darkroom, is drawing to an end.

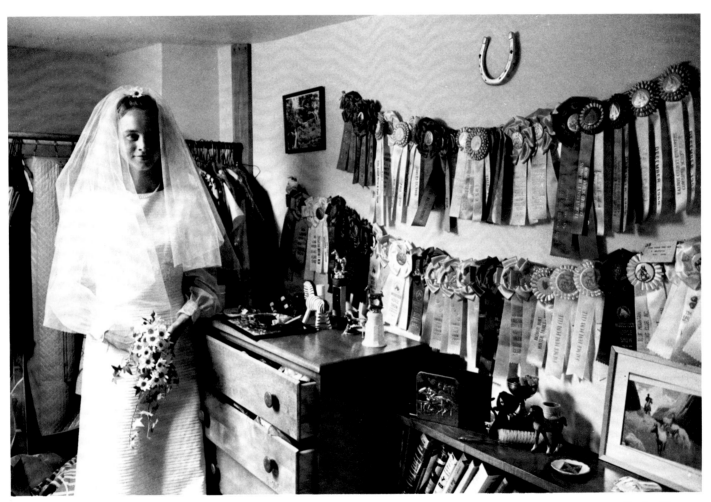

Katrina Thomas
c. 1970s

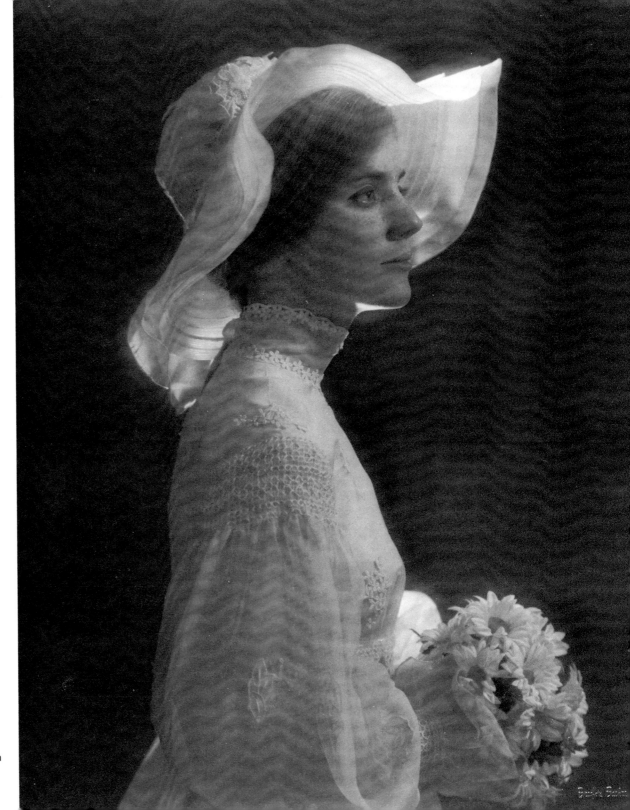

Bachrach Studio
East Coast
Black-and-white reproduction of a color photograph
1970

Bachrach Studio
East Coast
Black-and-white reproduction of a color photograph
1973

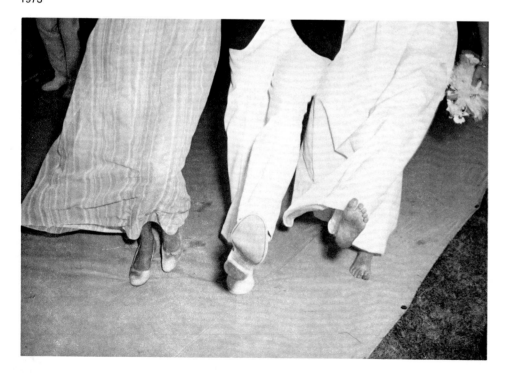

Joel Myerwitz
c. 1970s

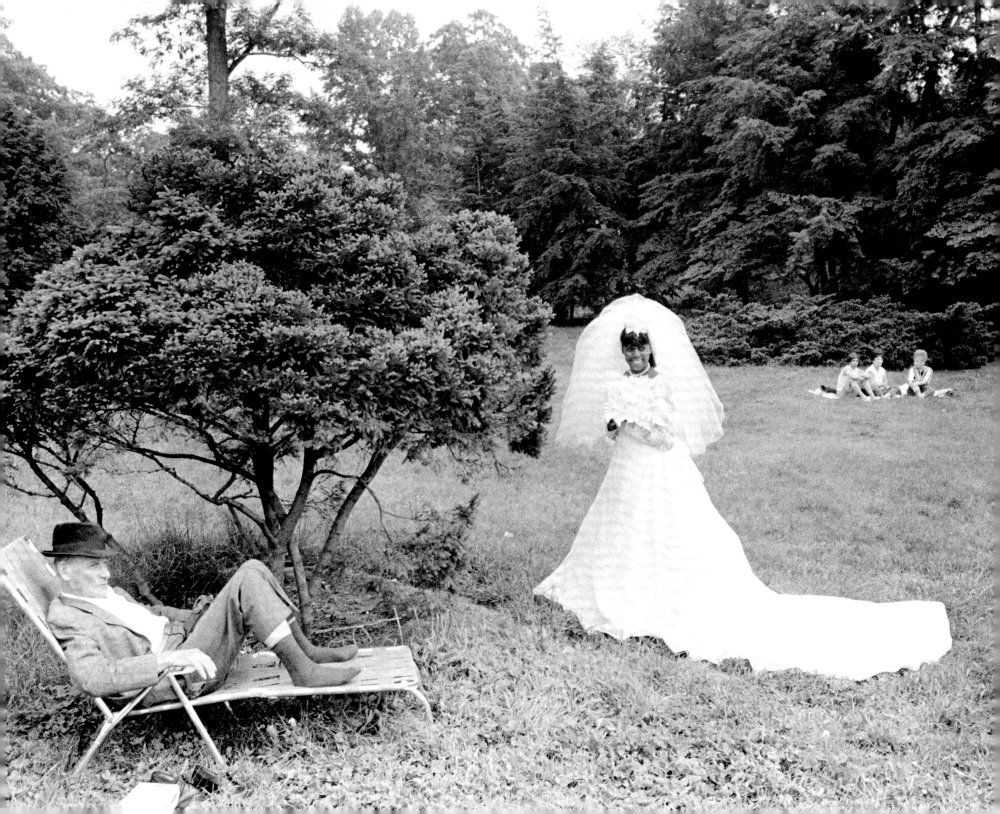

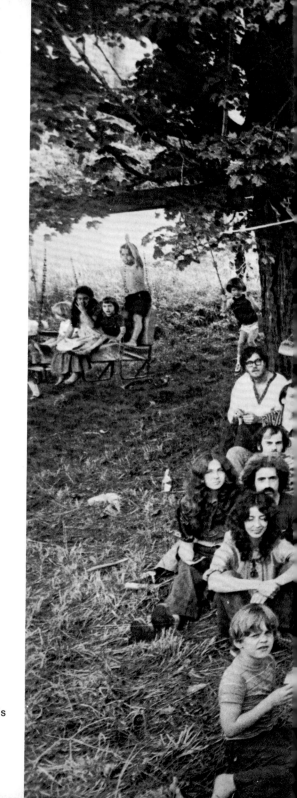

Peter Simon
Photograph of friends
Greenfield, MA
1973

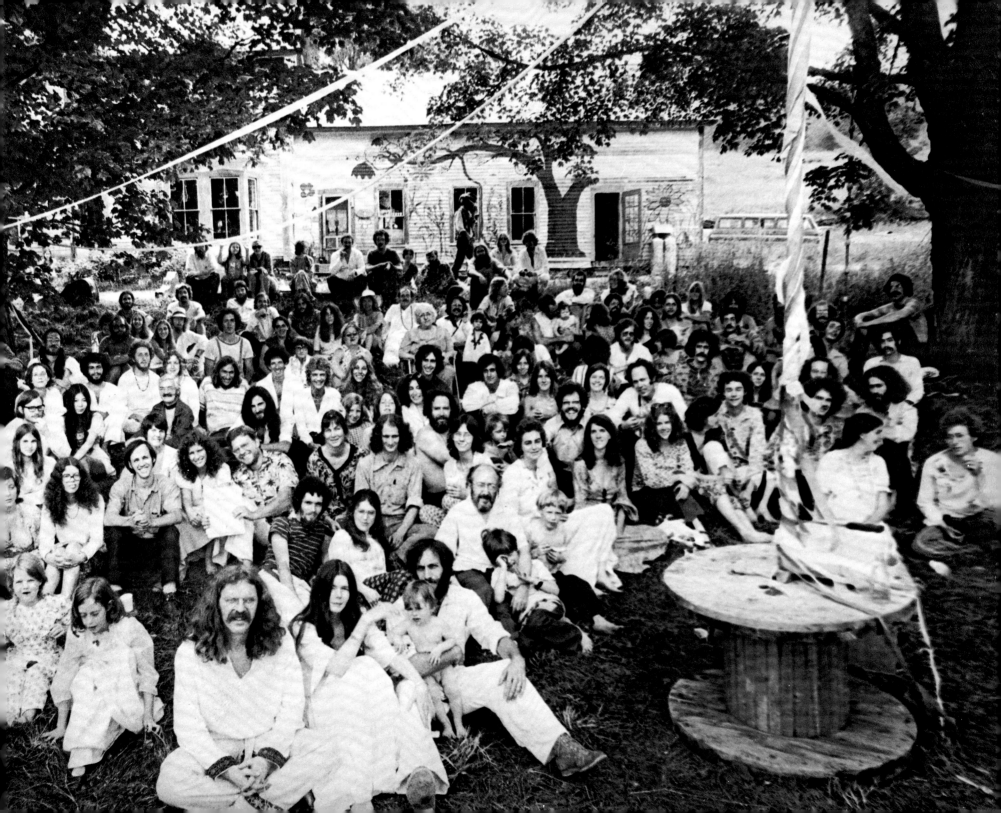

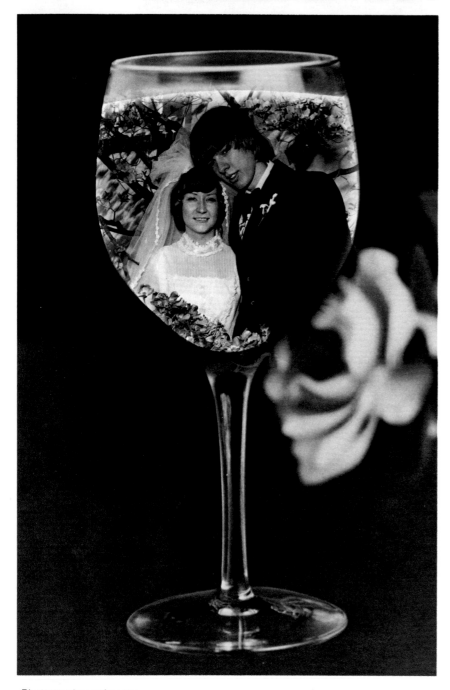

Photographer unknown
Color candid
Black-and-white reproduction of a color photograph
1976
Lent by Lydon Color Lab

Bachrach Studio
East Coast
Black-and-white reproduction of a color photograph
c. 1973

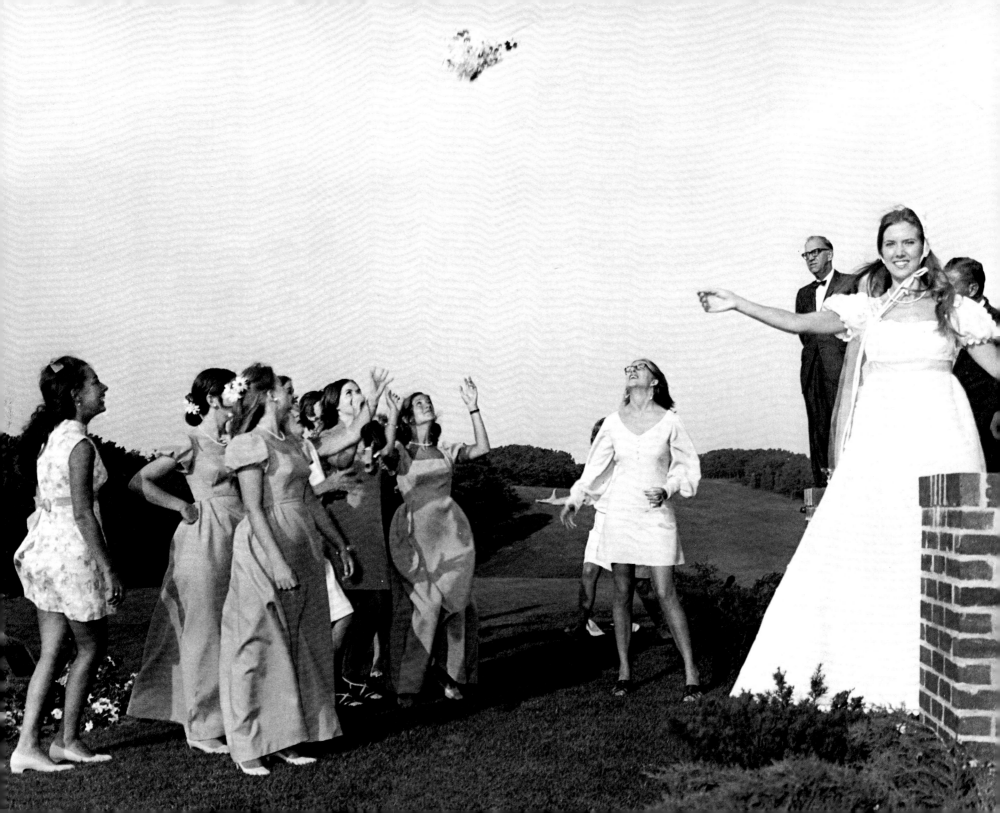

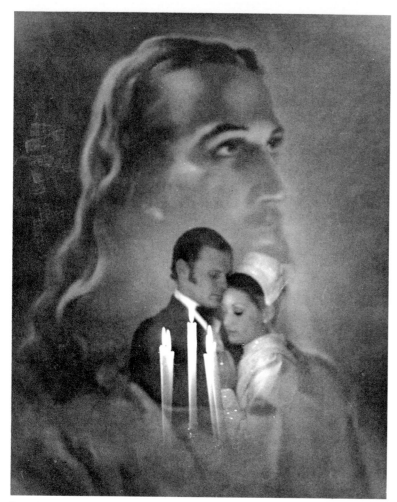

Dave Scanlon
Randolph, MA
Color candid
Black-and-white reproduction of a color photograph
1975

Snapshot
Bob Ely
1975

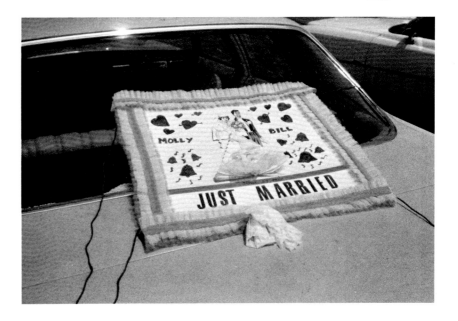

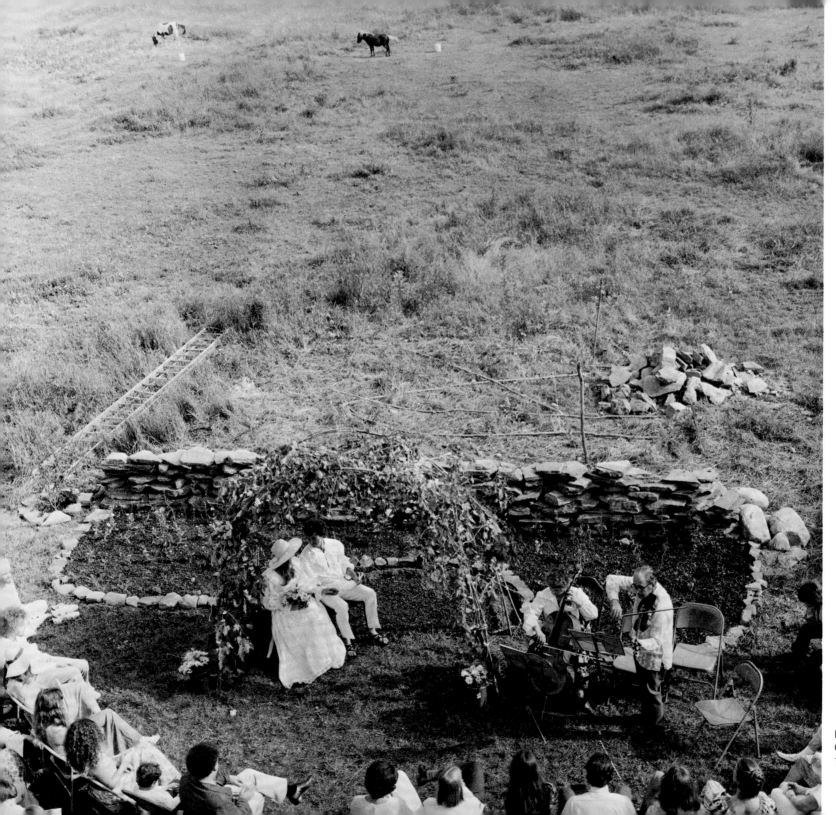

Peter Simon
Charlemont, MA
1974

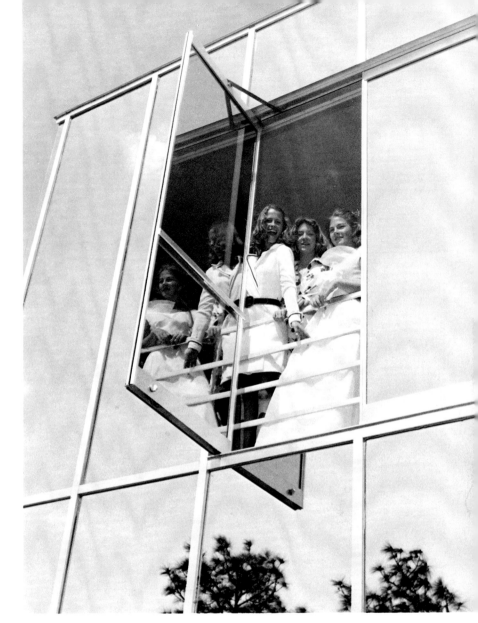

Bachrach Studio
East Coast
Black-and-white reproduction of a color photograph
1975

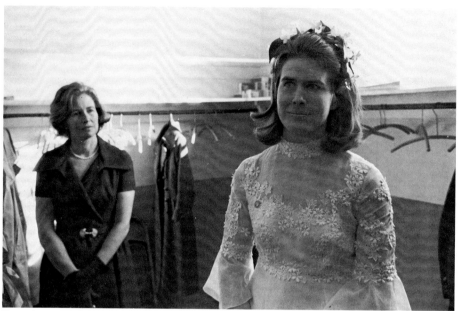

Snapshot
Jack Lueders-Booth
1975

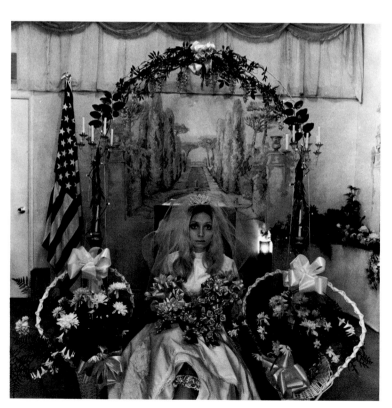

Linda Rich
Las Vegas, NV
1975

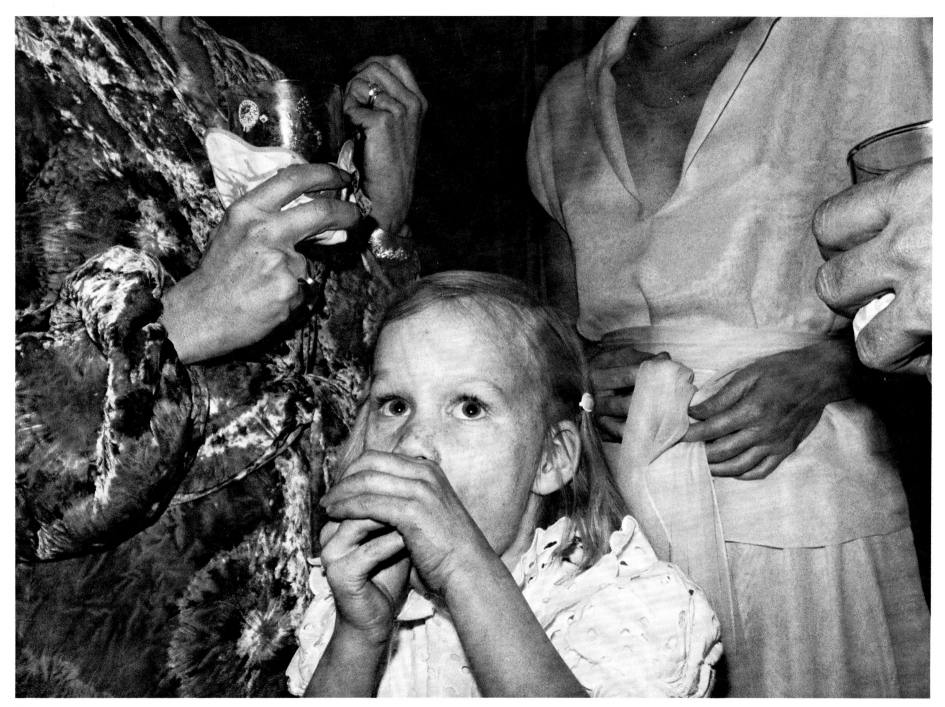

Stephen Shore
Amarillo, TX
Black-and-white reproduction of a color photograph
1975

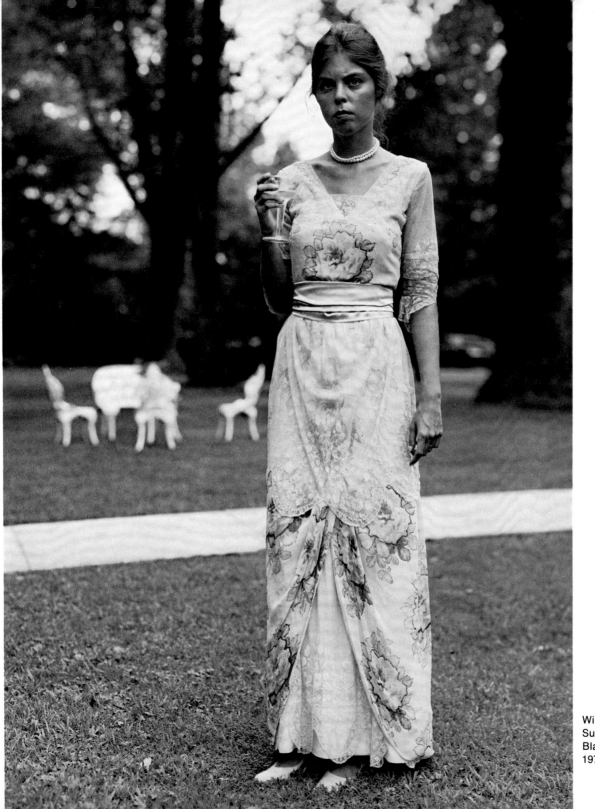

William Eggleston
Sumner, MS
Black-and-white reproduction of a color photograph
1974

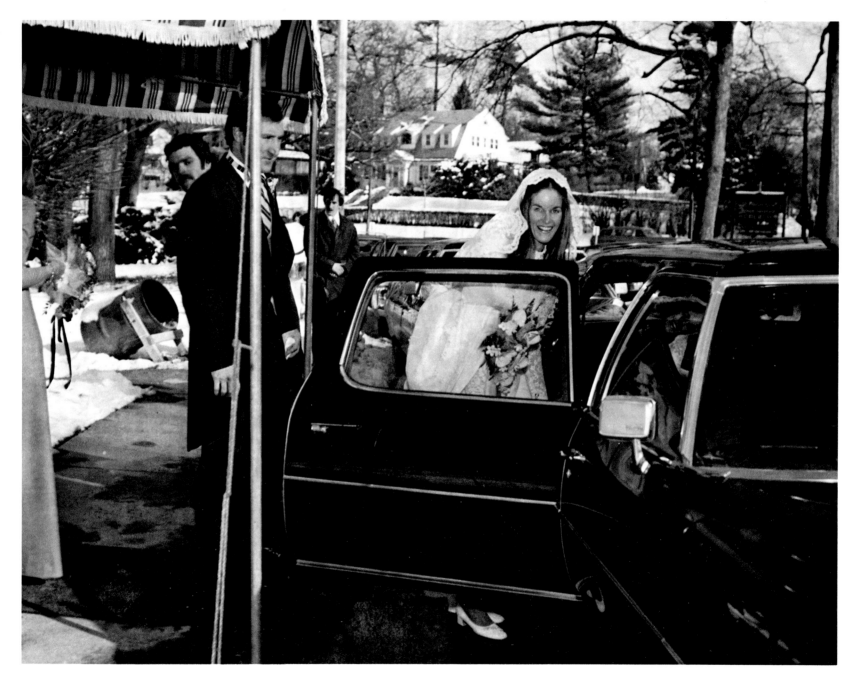

Bachrach Studio
East Coast
Black-and-white reproduction of a color photograph
1976

Barbara Norfleet is a lecturer and Curator of Photography at Harvard University, as well as Director of The Photography Archive at the Carpenter Center for the Visual Arts at Harvard. Born in Lakewood, New Jersey, Ms. Norfleet is a Swarthmore graduate, who majored in economics and psychology, later taking her Ph.D. in social relations at Harvard. She has lived in Massachusetts since 1948, and has been a member of the Harvard faculty since 1960, teaching psychology, sociology and, in recent years, visual arts.

In addition to the "Wedding" exhibition shown at Harvard University and the International Center for Photography in New York, Ms. Norfleet's other photographic exhibitions include "The Social Question," shown at Harvard and the Museum of Modern Art in New York, as well as several exhibitions of her own work. Her previous book of photographs, *The Champion Pig: Great Moments in Everyday Life,* was recently published by David R. Godine.

Barbara Norfleet was married in 1950, is the mother of three children, and counts gardening, tennis, cooking, and photography among her many interests.